IMAGES
of America

LIVINGSTON

IMAGES
of America

LIVINGSTON

Barry H. Evenchick

ARCADIA
PUBLISHING

Published by Arcadia Publishing
Charleston SC, Chicago IL, Portsmouth NH, San Francisco CA

Printed in the United States of America

Library of Congress Catalog Card Number: 9962233

For all general information contact Arcadia Publishing at:
Telephone 843-853-2070
Fax 843-853-0044
E-mail sales@arcadiapublishing.com
For customer service and orders:
Toll-Free 1-888-313-2665

Visit us on the Internet at http://www.arcadiapublishing.com

For William H. Clark (1904–1993),
who had the dream,
and Robert H. Harp (1921–1998),
who led it to reality.

CONTENTS

ACKNOWLEDMENTS

Mayor David Katz and Township Council members Eleanor Cohen, Joseph Fiordaliso, Dolly Luwisch, and Stanley Weinroth were enthusiastic about this project from the first time they heard about it and immediately adopted a resolution of support. That led to contacts with a number of people from town who thoughtfully provided information that I believe made many of the captions particularly enlightening.

Sincere appreciation goes to Ruth L. Rockwood Memorial Library Director Barbara Jean Sikora and to Arlene Boland of the library staff. They went to great lengths to be sure that the vast photographic collection of the library was made available for inclusion in this book. Similarly, E. Christopher Cone, Editor of the *West Essex Tribune*, and Assistant Editor Nancy Dinar allowed me to descend upon their offices on a number of occasions and sort through the archives for pictures of Livingston, past and present.

I am grateful to the members of the Livingston Historical Society, and in particular, Helen Shumsky, Carol Huck, and Phyllis Swain Kowalchuk, who provided access to the Force Home and shared their extensive knowledge of it. Township Manager Charles Tahaney and Deputy Manager Russell Jones, as well as Livingston Planning Director Joseph Roberts, spent considerable time sharing with me with their knowledge of the town and its history. Several other people were most helpful. Dr. Armond Forcella sent me a number of photographs and stories about old Livingston. Our mailman, Richard Manning, loaned me a rare book called *Livingston* (1939) by the New Jersey Writers' Project, which contains information that is unavailable elsewhere. Mrs. Doris Adamus, a former staff member of the Livingston Library, was more than generous in answering questions about historic sites and the persons who once did or still do occupy them.

I also wish to thank Jan Press, a professional photographer in Livingston. When Russ Jones gave me an old yellowed and decaying newspaper with a headline that I wanted to use in the book, I went to Jan's studio on S. Livingston Avenue, and by the next day Jan had produced a wonderful photograph of the newspaper (see p. 31).

Former New Jersey Governor Brendan Byrne was my first boss when I served under him as an assistant Essex County prosecutor. Brendan grew up in West Orange, but he knew and knows well many people in our community. His recollections, shared over a lunch or two, were invaluable.

This book might never have seen the light of day if Deborah Daidone, a word-processing "wizard" at my law firm, Hellring Lindeman Goldstein & Siegal, had not tolerated my writing peccadillos and corrected them. Thanks, Debbie.

Last but not least, I pay tribute to my wife, Linda. Love means never having to wonder whether she would be willing to proofread and edit every word in this book. She did, and also kept the coffee on during the late hours as deadlines approached. My only complaint is that while she served the coffee without reserve, she kept the cookies under lock and key.

INTRODUCTION

The uniqueness of Livingston is not likely to be apparent to an outsider. As a matter of fact, it takes some years even as a resident to understand what makes it so special. But there comes a time inevitably when one recognizes that to live or work in the town is both a pleasure and a privilege.

Chartered in 1813, Livingston was, for more than the first hundred years of its existence, largely farmland with a sparse population. With the arrival of the 1930s and '40s, and especially after World War II, the town developed rapidly. As open space became occupied with one-family houses, it became obvious that what was urgently needed was a blueprint for the future. Many citizens took part in the planning process. William Clark was perhaps the most prominent among them, but there are references in this book to a number of others. There came a time in the 1950s when a delegation was dispatched to a small town in Massachusetts called North Adams to meet with a young man named Robert Harp and to interview him for the newly created position of township manager.

Many recall that when Harp came to Livingston, he immediately exhibited qualities of strong leadership. There were times when all were not in agreement with him about what to do or how to do it. However, if there were occasions when his decisions were controversial, there was never a time when anyone questioned his motivation or his integrity. Harp could be tough, but he was eminently fair and always willing to listen to another point of view.

Speaking about Bob Harp brings us to the subject of volunteerism. As busy as he was carrying out his executive duties, he participated in virtually every other activity that went on in the town. So did other leaders like Charles Schilling, William Clark, Herbert Mitschele, John Duetsch, Kenneth Welch, Dominick Crincoli, and Doris Beck. What all of these people had in common was a sense that in order to achieve a high quality of municipal life, citizens had to band together and work in the various service organizations and committees, designed to regulate and improve the quality of day-to-day life. One gets caught up in the spirit. It is infectious, and it is what makes this place so special.

And so, as the pictures in this book show, the farmland has turned into homes and offices and businesses. There are many homes, some quite luxurious and some relatively modest, but they are in close proximity to one another. The people who occupy them live, work, and play together and do so in harmony. What is it like to live in Livingston? Perhaps the following words from Alexander Pope's *Ode on Solitude* answer the question:

> *Happy the man, whose wish and care*
> *A few paternal acres bound,*
> *Content to breathe his native air,*
> *In his own ground.*

One

THE EARLY YEARS

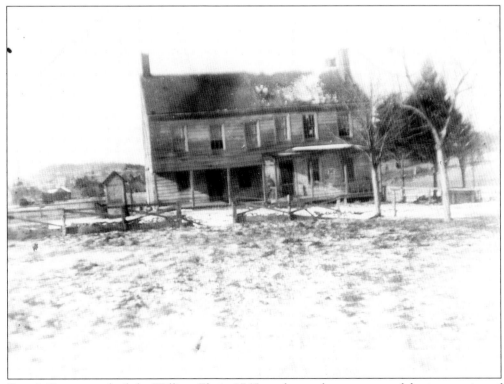

Samo's Tavern was built by William Ely in 1765 on the southwest corner of the intersection of Livingston and Mt. Pleasant Avenues. The Township of Livingston organized and held its first election there on April 12, 1813. The building became the Livingston Hotel in 1834. Shown here in 1904, it was torn down in 1906. Today there are retail stores on the site.

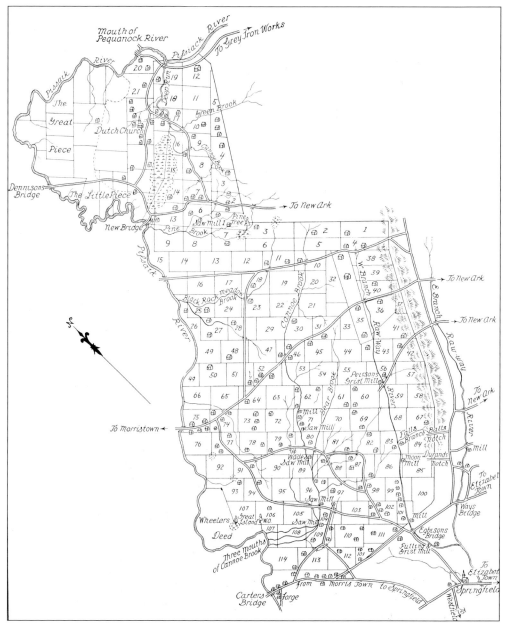

The Horseneck Tract extended from what is now Springfield and Maplewood at the south to West Caldwell and Fairfield at the north. The present township of Livingston is located in the middle of the larger portion of the tract. The road indicated as running between Morristown and Newark was the forerunner of the present Mt. Pleasant Avenue.

Four grades met in the primary room of District School No. 2 in Northfield Center, shown here in September 1904. Northfield Center is where S. Livingston Avenue and Northfield Road intersect. On this site today stands a brick building that once housed Roosevelt School and, for the last 25 years, has been known as Roosevelt Plaza, containing shops on the first floor and offices above.

The farm and farmhouse pictured in this 1900 photograph were situated on the north side of Mt. Pleasant Avenue, west of Livingston Avenue. Today the area is composed of retail stores.

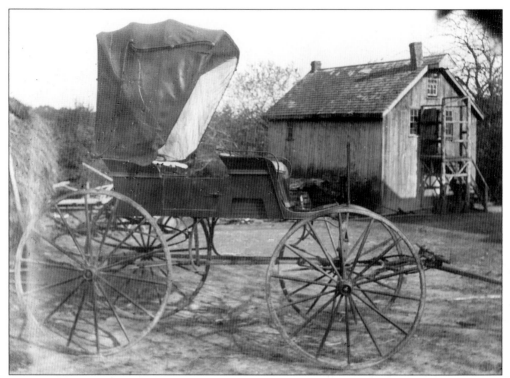

This carriage, owned by Livingston's Samuel Burnet ("Uncle Samuel"), transported the Marquis de Lafayette across New Jersey during his visit to America in 1824–25. The picture was taken in April 1900 by William H. Gardner, a writer for the *Newark Evening News*. Copies of the photograph are in the Smithsonian Institute in Washington, D.C., and in the collection of the New Jersey Historical Society.

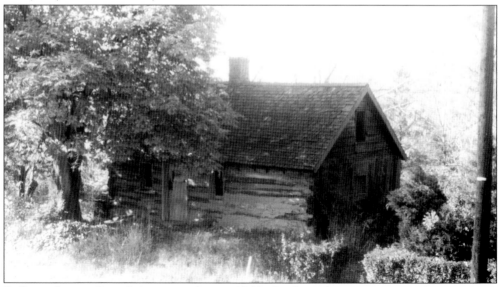

Still standing on Laurel Avenue as late as 1966, this log cabin is now gone, but numerous homes remain on the street (which extends from Livingston on the south to West Orange on the north).

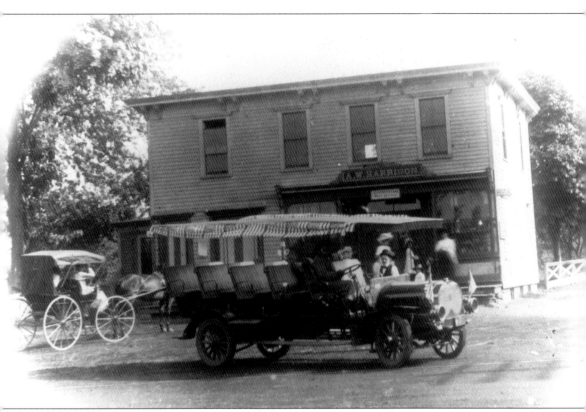

The A.W. Harrison General Store can be seen in the background of this *c.* 1915 photograph. Amos Harrison was also the postmaster. The post office and general store were downstairs, and there was a hall upstairs that was used for official meetings and elections. In the foreground is the first motorized DeCamp bus.

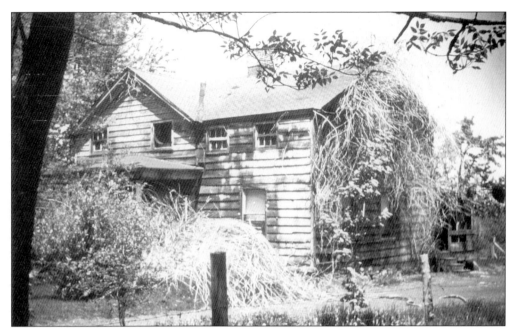

This was the Titus Force Home on Mt. Pleasant Avenue. It was torn down in about 1950 and eventually replaced by the Salaam Temple, which still occupies the site.

Taken around 1875, this photograph shows the Ely General Store on the southeast corner of Livingston and Mt. Pleasant Avenues. The Ely family were highly successful business people. John Ely operated a shoemaking factory behind his home on Mt. Pleasant Avenue.

14

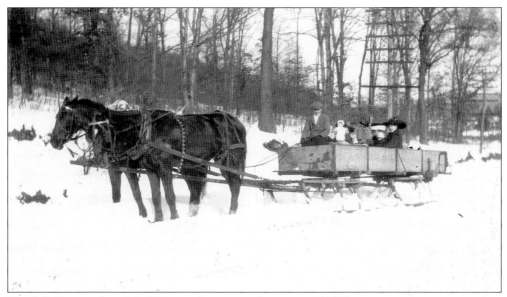

Sleigh bells ring along Mt. Pleasant Avenue in the winter of 1900.

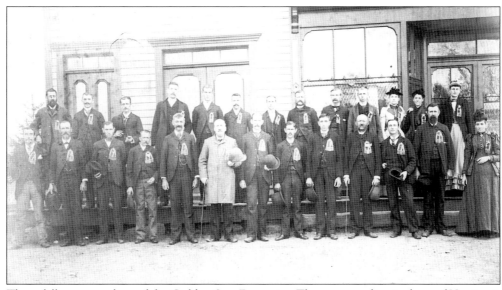

These folks are members of the Golden Star Fraternity. They are standing in front of Harrison's general store, Livingston Center.

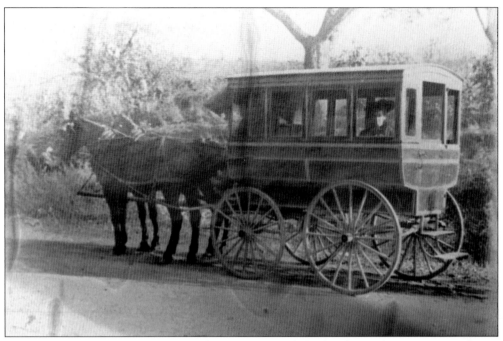

Here is the famous DeCamp stagecoach, c. 1900. It was the last horse-drawn accommodation and was replaced around 1909 with a motorized bus that was used mainly for sightseeing.

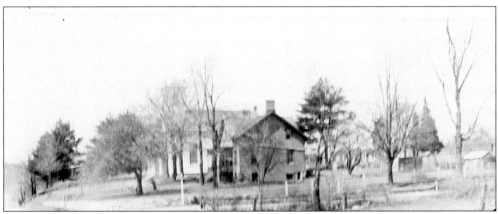

Taken in 1900 by Pastor William Gardner, this photograph is of the Livingston Baptist Church and parsonage at the northwest corner of Mt. Pleasant Avenue and Livingston Avenue. The latter, at the time of this photograph, was called "Rosebud Road."

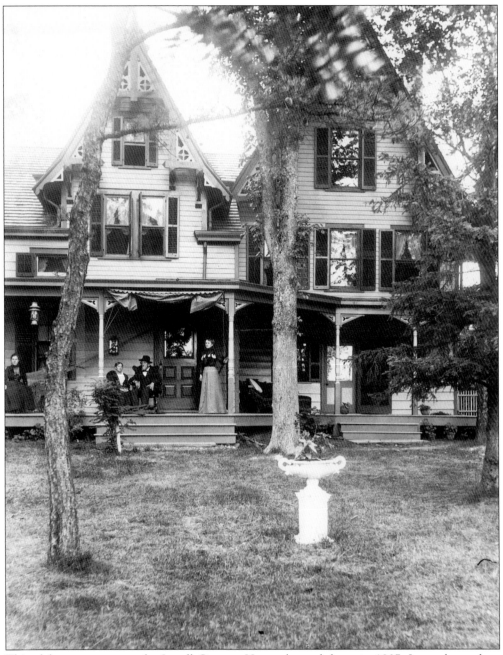

This elaborate structure, the Jewell-Genung House, burned down in 1907. It was located on Walnut Street on the site of what later was to be the Genung residence at 191 Walnut Street.

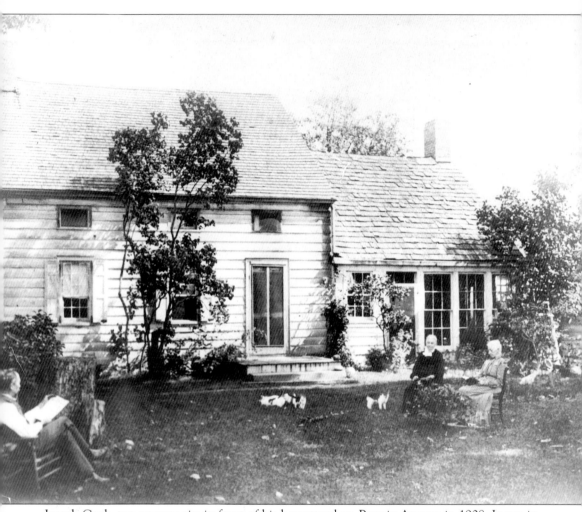

Joseph Cook, tax assessor, sits in front of his homestead on Passaic Avenue in 1908. It was in that year that Roseland withdrew from Livingston.

The Gilbert Squire House, shown here in 1963, was on the east side of Walnut Street across from Cedar Hill Country Club. It stood from the Revolution until it was torn down in 1976. Gilbert Squire was a descendant of Jonathan Squire, who, with two others, developed a section of Livingston on the west side of town that became known as Squiretown.

The Grannis-Rousch House is located at 135 N. Livingston Avenue. While the photograph was taken in 1981, the structure dates back to the 19th century. It remains one of Livingston's historic treasures.

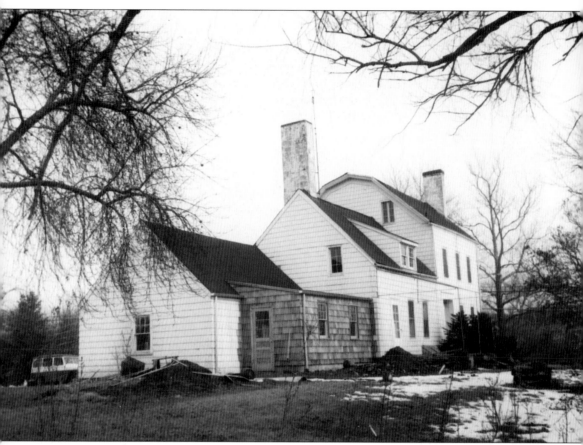

Livingston's most famous historic site is the Force Home. Built in 1752, it is on S. Livingston Avenue and is the headquarters of the Livingston Historical Society.

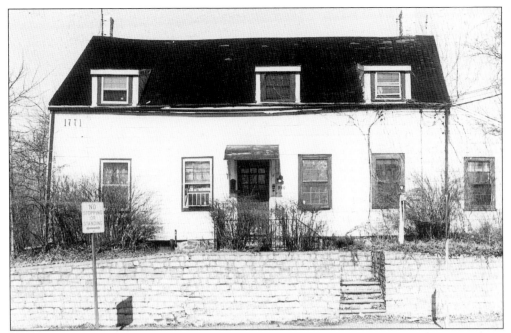

The Henry Wade House, which was listed on the Historic American Building Survey of the National Park Service, was on the west side of Livingston Avenue near Northfield Center. Built in 1771 from timbers Wade prepared at his sawmill, it remained standing until 1979, when it was removed. The lot remains vacant.

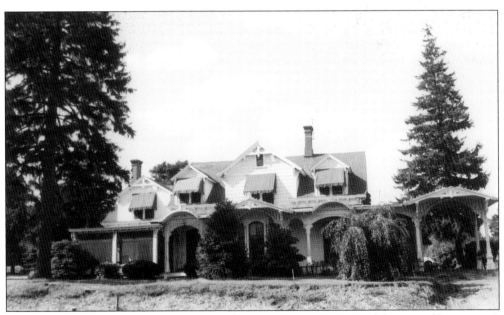

Built in 1810, the Ely House on W. Mt. Pleasant Avenue was named for one of Livingston's first residents, William Ely, a captain in the British Army. Samo's Tavern (also called "Uncle Billy's"), where the first township meeting took place in 1813, was built by Captain Ely's son, William Ely Jr. (see p. 9). There is a small shopping center on the site today.

Parker Teed was a member of the Teed family, whose roots in Livingston go back to 1757. His house was located at 26 Teed Road, but was demolished in 1961. Teed Road, once located near Knollwood Drive, no longer exists.

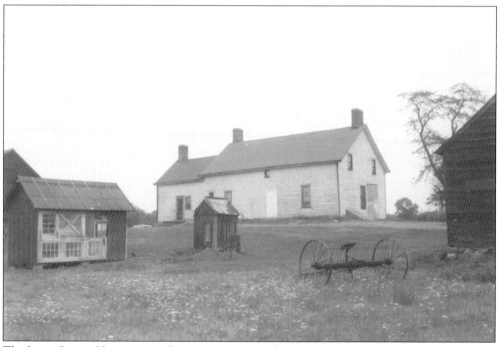

The James Brown House was on Passaic Avenue in what is now the East Orange Water Reserve. It was built in the 18th century but was razed in the early 1960s.

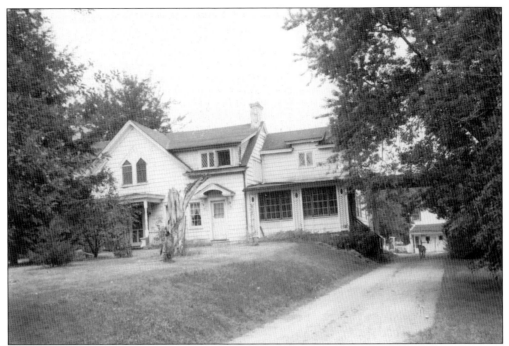

This house, built by Andrew Miller Kent in the late 1800s, is called the Kent-Stevens-Spurr-Collins House. Located at 256 W. Hobart Gap Road, it was once owned by Livingston Township Committee Chairman Joseph James Spurr II, and later by Councilman/Mayor John Collins.

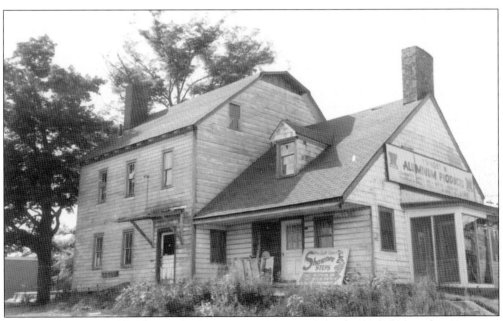

Ely Tavern, located at 111 W. Mt. Pleasant Avenue, opened in 1798 and remained in operation until about 1807, when the structure became the home of Mrs. Sara Blodgett. Years later, if you needed aluminum goods or pre-cast concrete steps, this was your store. In 1967, the building was demolished (see p. 68).

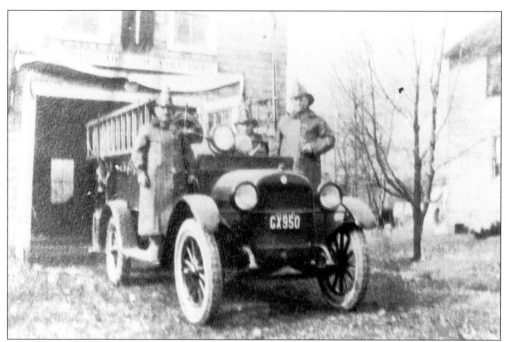

The "Mary Ann," shown parked in front of Livingston's first firehouse, was Livingston's first fire truck. She played a prominent role in the township's 125th anniversary festivities in 1938.

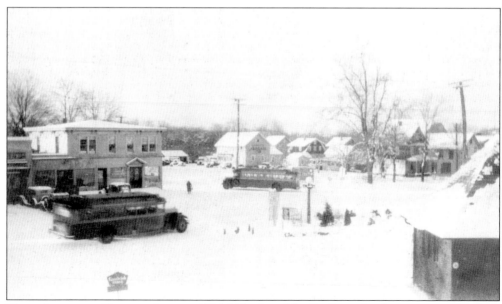

This is Livingston Center in January 1934. Vehicles of the DeCamp Bus Lines are seen heading in different directions. The large building on the left is where Gail Lowenstein's real estate office is now located.

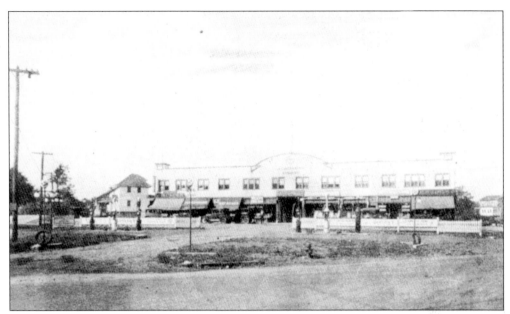

Here is a somewhat earlier photograph of Livingston Center (in the 1920s) in an area that is still referred to as the "plaza." It was built by a man named Gottlieb Hockenjos. This photograph was taken from Mt. Pleasant Avenue and shows what is the northeast quadrant of the intersection of Mt. Pleasant Avenue and Livingston Avenue (visible on the far left).

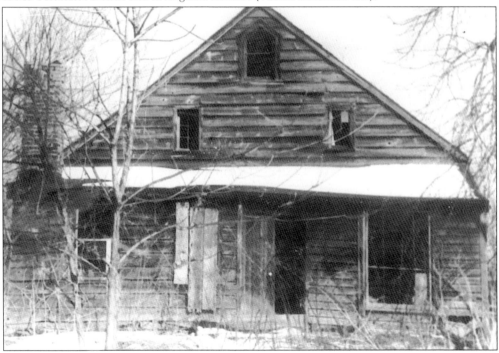

Samuel Burnet's tavern, pictured here in 1950, was located in the vicinity of Northfield Road and Hobart Gap Road. Built in 1799, it served as a tavern until 1836, when it closed. The structure no longer exists, but today, not far from its site, is Nero's Grille, a popular restaurant and meeting place.

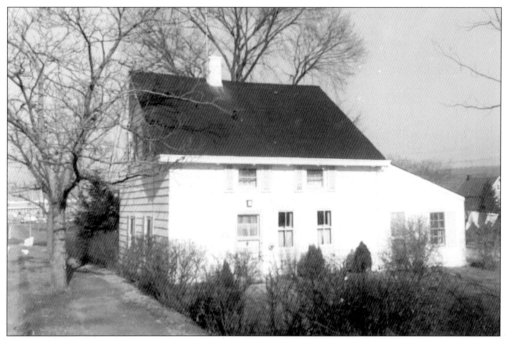

Benjamin Bedford was an early settler of Livingston. His house, which no longer exists, was located on the corner of Old Road and Walnut Street. One of Livingston's original schools was built on Old Road not far from this site.

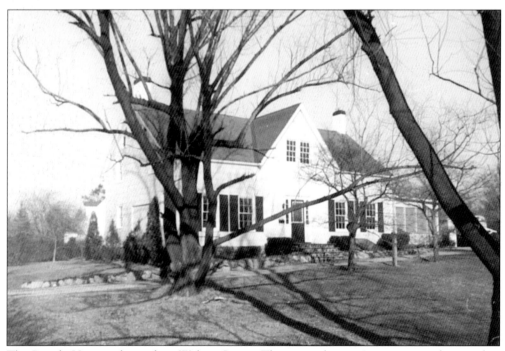

The Parmly House is located on Walnut Street. The original owner's name is not known, but the property was purchased by Alexander Parmly in about 1839.

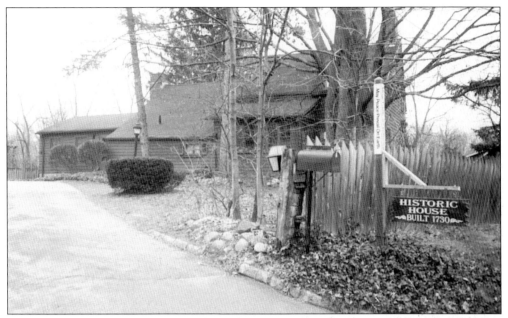

The Beach House, built in 1730, is located on Beaufort Avenue near Riker Hill. There is a story that a large tree, 10 feet in circumference, grew on the property after being planted by Phoebe Beach. Phoebe had pulled a stick out of the ground in order to whip her horse; when she discovered the stick had roots, she planted it, and the tree resulted, or so the story goes.

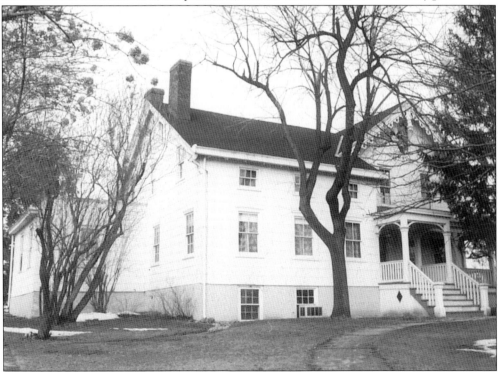

Andrew Teed became the postmaster in Livingston in 1852. This was his house on Mt. Pleasant Avenue. The post office originally was located in the basement of this house.

The Collins family goes back to the 19th century in Livingston. In 1939, Pell Collins was the secretary of the township's board of assessors. His house, pictured here, was on S. Livingston Avenue.

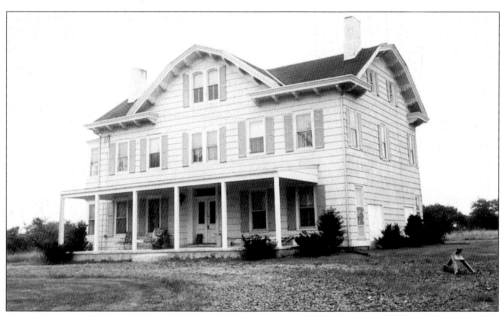

From the second floor of the old Crane House, one could look across Walnut Street to the Livingston Methodist Church, which was built by a member of the Crane family. The Cranes started a dairy business in Livingston in about 1858.

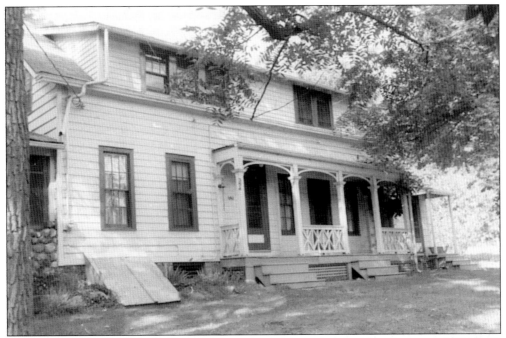

The Tompkins House on Beaufort Avenue is one of Livingston's oldest. It was probably built in the late 1700s. One John Tompkins is believed to have been born here in 1806 and is said to have died here in 1903. History does not record who built the house or who lived in it originally.

These were some of the milk sleds used by members of the Henry Becker family as they sold their milk in Livingston and neighboring communities. One of the old-time members of the family is reported to have recalled that the milk always got through, except for one occasion in the Blizzard of 1888 when one of the sleds literally was buried under the snow.

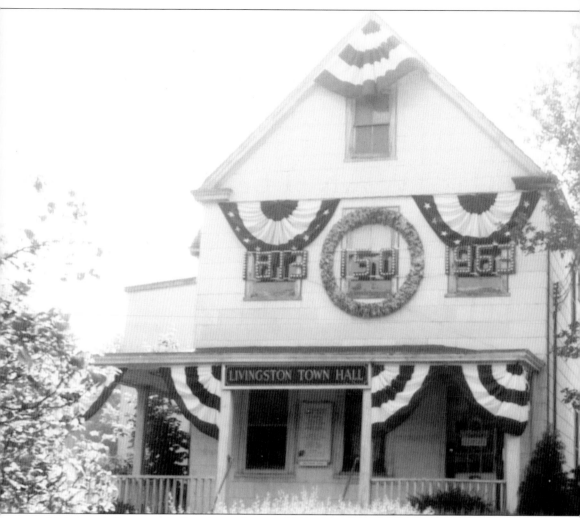

Livingston's first town hall is shown here in 1963, the 150th anniversary of the town. It was built in the 1930s on Berkeley Place. The town hall then and now (the current one is on S. Livingston Avenue) is where the township council meets on Monday nights. The building also houses the municipal court and the administrative offices of the town government.

Two

THE WAR YEARS AND TRANSFORMATION

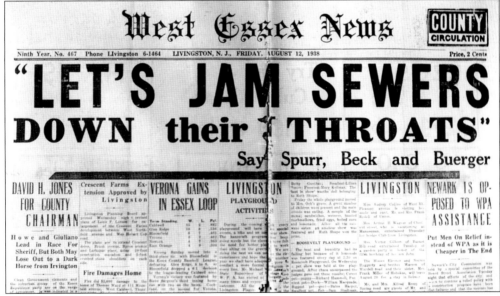

Obviously, whether a sewer system was going to be required for the town was a highly emotional and controversial subject. The headline of the *West Essex News* on August 12, 1938, presents the view of three members of the local government.

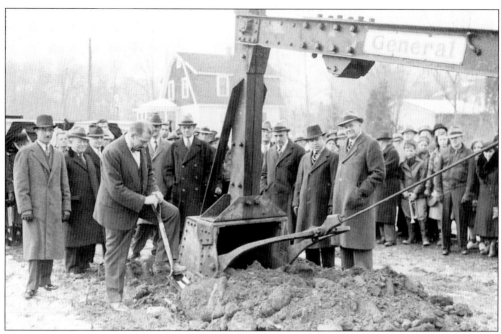

Standing to the left of the man with the shovel is Herbert Mitschele, one of Livingston's most famous personalities. He served longer on the township committee than any other person in history, and is seen here breaking ground for the installation of Livingston's new sewer system, December 3, 1938.

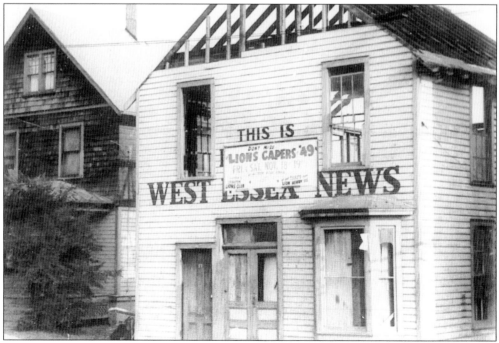

This was the home of the *West Essex News,* located on W. Mt. Pleasant Avenue. The sign is advertising a Lion's Club function, apparently in 1949, to be held at the new high school.

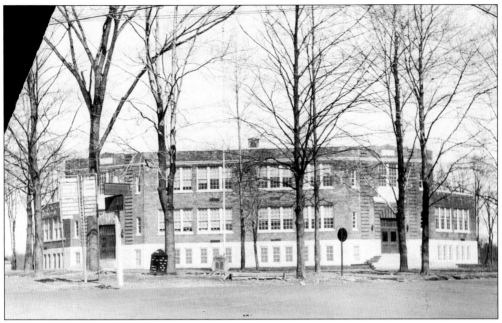

Roosevelt School, on the northwest corner of the intersection of S. Livingston Avenue and Northfield Road, is pictured here in 1927. It was used as a school until the early 1970s, when it was sold by the board of education to a group of businessmen, who retained the basic structure but converted it into today's "Roosevelt Plaza," containing shops and offices.

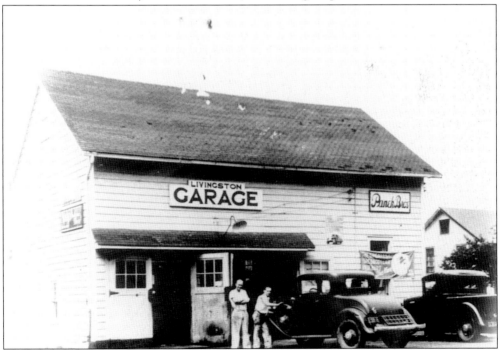

Panek's Garage, located in Livingston Center and shown here in the 1920s, was not only for the servicing and repair of automobiles, it was also one of the several unofficial places in town where "everyone" gathered from time to time to discuss matters of the day.

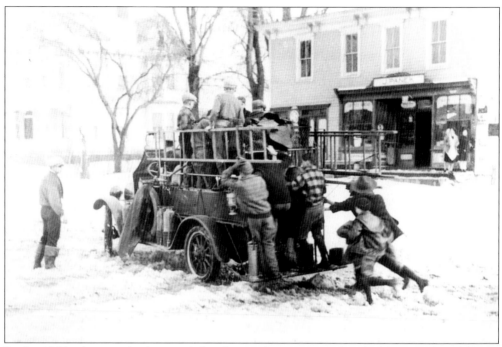

In this 1920s photograph, the town's first fire truck is seen outside a building purchased by the Panek family in 1923. The building became the Livingston National Bank in January 1928. The home of postmaster and education leader Amos Harrison is visible on the left.

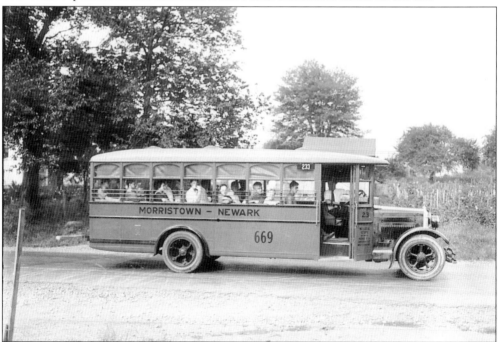

The Morristown to Newark DeCamp bus no. 233 passes through Livingston in the 1920s. The DeCamp family pioneered the transportation business in town and, for a considerable time, provided the only means of mass transit in the area.

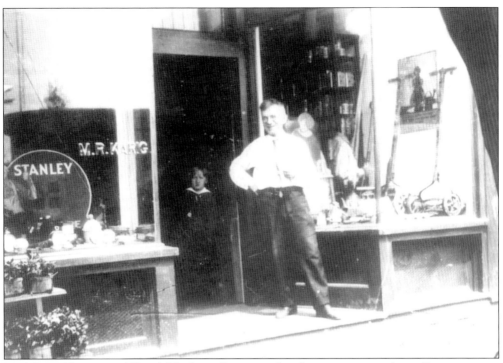

Mr. Martin Karig owned Karig's Hardware Store, another favorite meeting place of Livingstonites in the 1920s and 1930s.

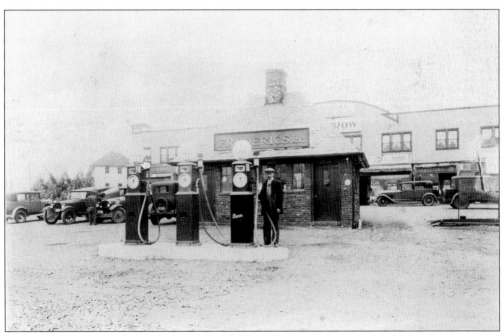

Livingston Center is shown here in the 1930s. The gas station occupied what is now called "Lions Park." The station no longer exists, and the land where it stood is now used primarily as a parking lot, in front of which there is a small grassy area containing a flagpole and a monument.

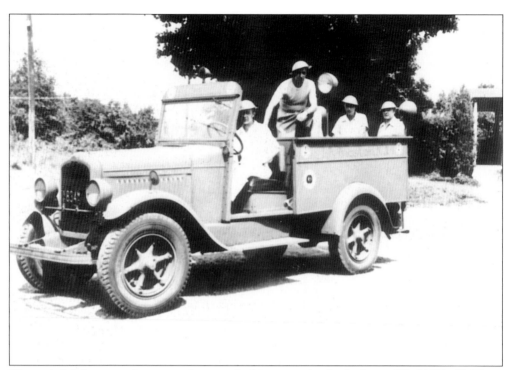

These civil defense wardens were photographed in a patrol vehicle during World War II. There was a period when people believed an air attack could come at any time and that survival depended upon providing suitable shelters and turning lights out at night .

There were few things more important to the war effort than the collection of scrap substances used in manufacturing defense materials. Here are volunteers in a truck engaged in the process somewhere in Livingston.

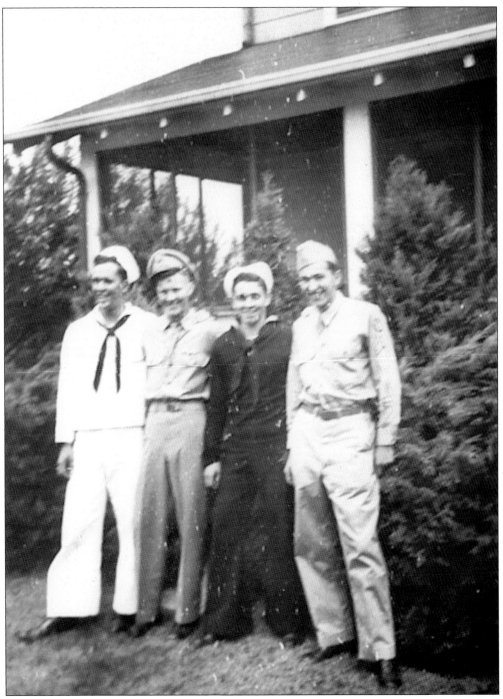

The four Livingston men shown here did their part in World War II. They are, from left to right, Bob Volk (Navy), "Red" Jones (Air Force), Kenneth Welch (Navy), and Willard Adamus (Army). Welch would later serve as Livingston's mayor.

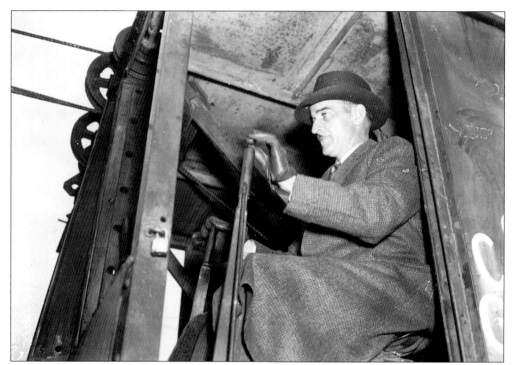

Herbert Mitschele is at the controls of a piece of equipment operating Livingston's new sewer system in 1938. Judging from his attire, this was a staged picture.

In the 1930s, the Livingston Police Department was relocated from a garage behind Chief Ashby's house to this building on S. Livingston Avenue.

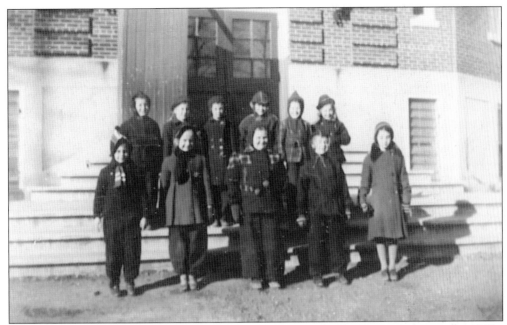

These students are standing in front of the Roosevelt School sometime during the 1930s. When the building was sold for commercial use 40 years later, the new owners preserved the basic structure.

This picture, taken in the Livingston Baptist Church in the 1930s, shows members of Livingston's junior fire department. They are, from left to right, as follows: (seated) Dudley MacArdle, Ralph Grossman, and John Stoll; (standing) Ruben Ivens, Dudley Van Idistine, unidentified, and Robert Oakley.

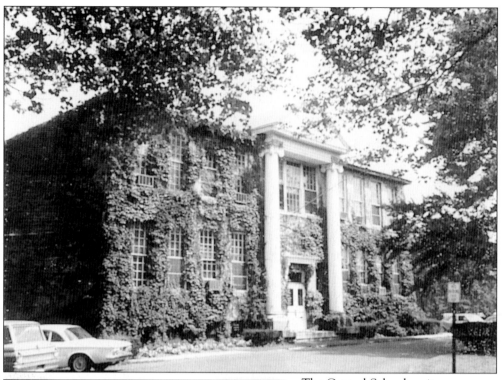

The Central School, as it was once known, was used mainly for the seventh and eighth grades. It appears here sometime after being modernized in 1930. In the 1960s, it was sold and became the Weight Watchers building.

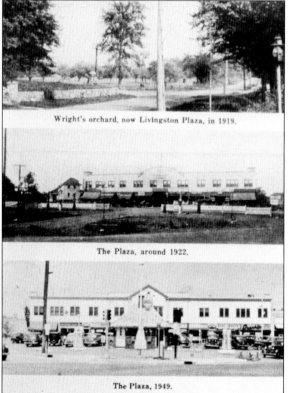

Wright's orchard, now Livingston Plaza, in 1919.

The Plaza, around 1922.

The Plaza, 1949.

These views of the Plaza (at the northeast corner of the intersection of Mt. Pleasant Avenue and Livingston Avenue) show the area in 1919, 1922, and 1949.

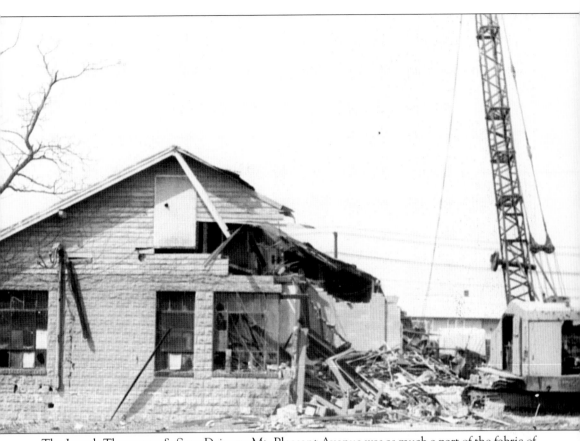

The Joseph Thompson & Sons Dairy on Mt. Pleasant Avenue was as much a part of the fabric of Livingston life as any institution. Originally, the farm comprised about 100 acres. In the 1930s, the milk was actually produced in Sussex County and brought to Livingston to be pasteurized and bottled. The dairy is shown here being removed in April 1971.

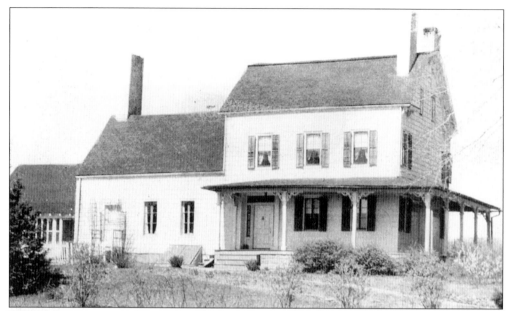

Here is a 1938 picture of the Force Home. The section in the middle is the original one-room home, which was built by Theophelous Ward in the late 1740s. The house was enlarged by Thomas Force after the Revolutionary War.

Livingston's first police department building was located in an unused garage behind Chief William Ashby's house. This photograph was taken prior to 1936.

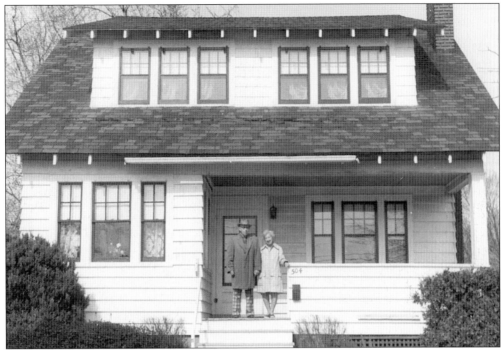

The first building permit issued in Livingston was for this house at 504 S. Livingston Avenue. It was constructed in the 1920s, although this picture was taken on March 4, 1981. Standing in front of the house are Mr. and Mrs. George Ferguson, the owners.

Livingston has always had a volunteer fire department, and it is probably the largest community in the state with one today. Junior firemen are shown here in 1939 being trained to take their places in the department.

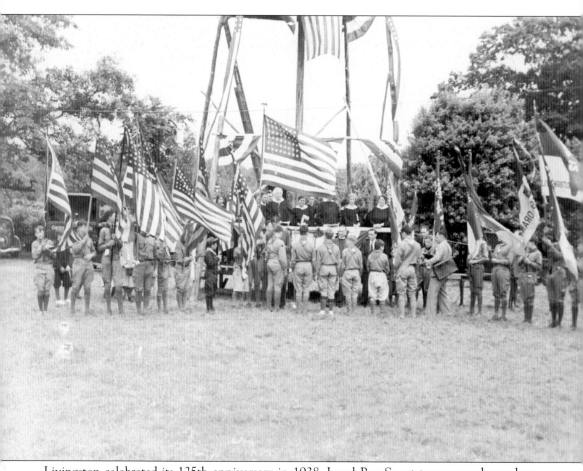

Livingston celebrated its 125th anniversary in 1938. Local Boy Scout troops are shown here participating in the celebration.

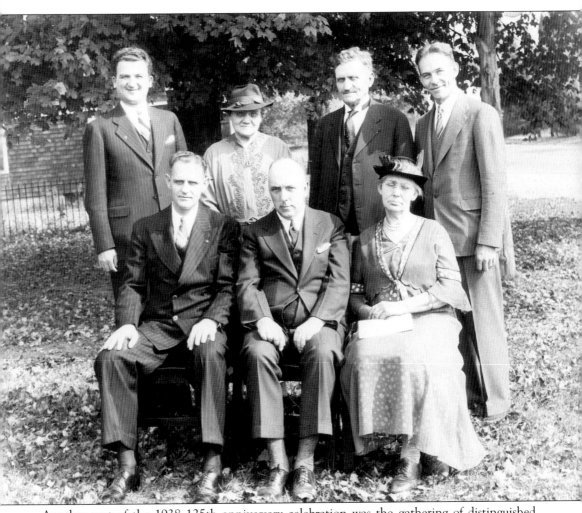

Another part of the 1938 125th anniversary celebration was the gathering of distinguished citizens. Those shown here are, from left to right, as follows: (seated) Leo N. Fisher, Freeman Harrison (Livingston Township Committee chairman), and Lilas Cooke.; (standing) Edward Gaulkin (township attorney and later a New Jersey Superior Court judge), Martha E. Devey (township librarian), George Schulte, and Rev. M.L. Lawrence (Livingston Baptist Church).

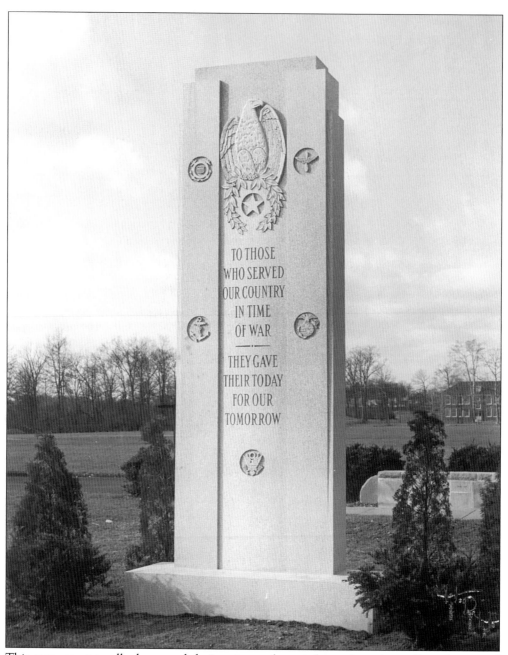

TO THOSE
WHO SERVED
OUR COUNTRY
IN TIME
OF WAR
———
THEY GAVE
THEIR TODAY
FOR OUR
TOMORROW

This monument to all who served during times of war is located on the mall to the east of Livingston High School. In the time since this picture was taken, other monuments have been added to the area to commemorate the contributions of Livingston residents in the Korean and Vietnam Wars.

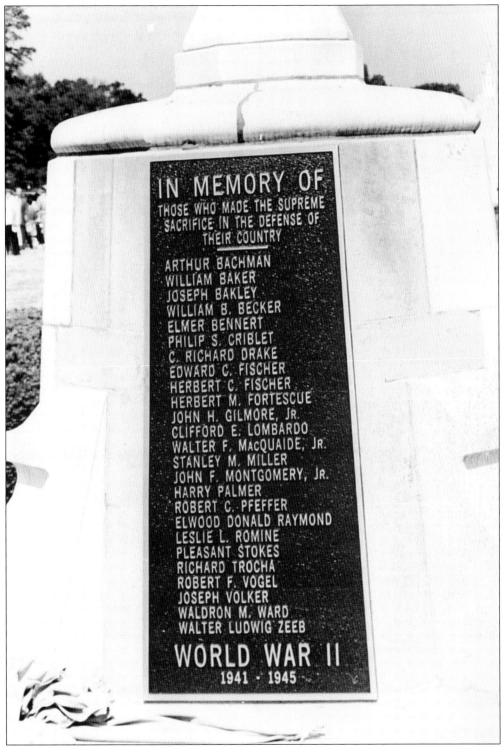

IN MEMORY OF

THOSE WHO MADE THE SUPREME
SACRIFICE IN THE DEFENSE OF
THEIR COUNTRY

ARTHUR BACHMAN
WILLIAM BAKER
JOSEPH BAKLEY
WILLIAM B. BECKER
ELMER BENNERT
PHILIP S. CRIBLET
C. RICHARD DRAKE
EDWARD C. FISCHER
HERBERT C. FISCHER
HERBERT M. FORTESCUE
JOHN H. GILMORE, JR.
CLIFFORD E. LOMBARDO
WALTER F. MacQUAIDE, JR.
STANLEY M. MILLER
JOHN F. MONTGOMERY, JR.
HARRY PALMER
ROBERT C. PFEFFER
ELWOOD DONALD RAYMOND
LESLIE L. ROMINE
PLEASANT STOKES
RICHARD TROCHA
ROBERT F. VOGEL
JOSEPH VOLKER
WALDRON M. WARD
WALTER LUDWIG ZEEB

WORLD WAR II
1941 - 1945

This monument, also on the mall east of the high school, lists those who gave their lives in World War II. It was built in 1947.

Livingston soldiers who volunteered for service during the Civil War are listed on this monument, located between the high school and Livingston Town Hall.

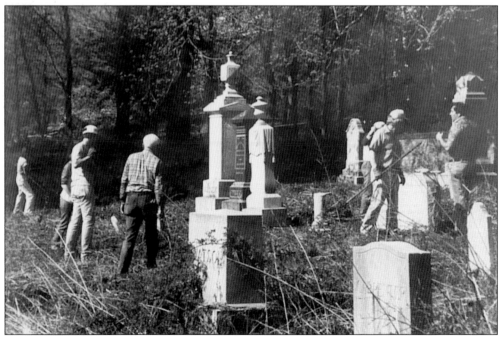

This is the Ely Cemetery on Hillside Avenue. It is of great historic importance and is maintained by Livingston service organizations, including those people shown here, members of the Livingston Kiwanis Club and Livingston Key Club.

Three

A MUNICIPAL PERSONALITY EMERGES

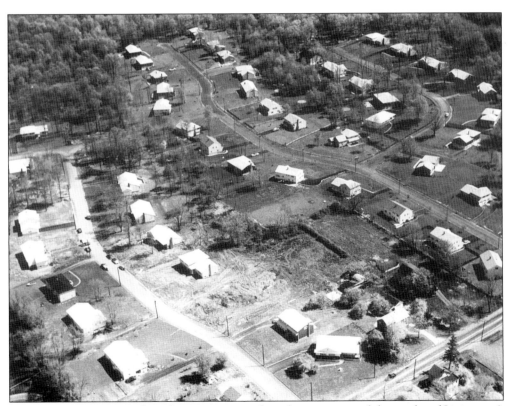

World War II was over when this picture was taken showing some of the results of Livingston's planning and development, primarily as a bedroom community. This area includes Millstone Drive, Blackstone Drive, and Stonewall Drive (on the western side of town near the Route 10 circle).

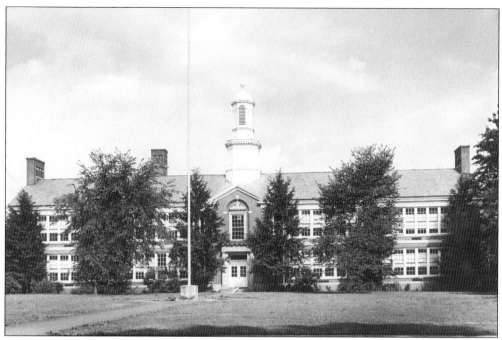

Opened in 1929, the Harrison School on N. Livingston Avenue is shown here about 1950. It was named in honor of Livingston's foremost educator, Amos W. Harrison.

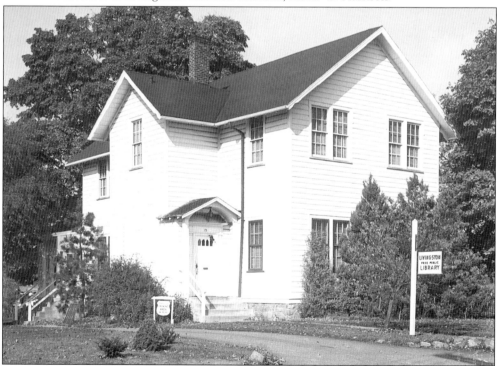

The Livingston Free Public Library was photographed on October 15, 1951, when it was located on E. Mt. Pleasant Avenue. The library moved to its present location on the mall (see p. 103) in 1961.

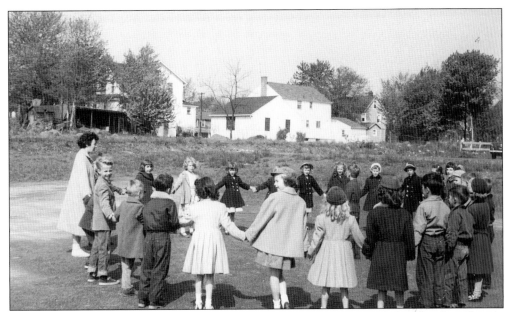

First grade students at the Monmouth Court School are shown here with their teacher, Eleanor Jennings, during physical education. The game they are playing is called "Ball in the Ring." The picture was taken on May 11, 1954.

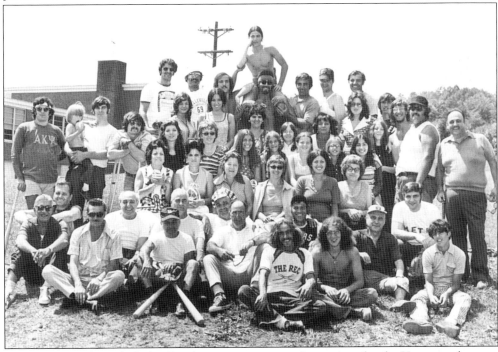

The Bottittas of North Ridge Road were a prominent Livingston family. Here, two bats are displayed in front of patriarch Anthony Bottitta. This picture, taken on August 6, 1972, is of the annual family gathering, which featured a ball game followed by a picnic. Somewhere in here is Anthony's son, Joseph A. Bottitta, Esq., the 1999 president of the New Jersey State Bar Association.

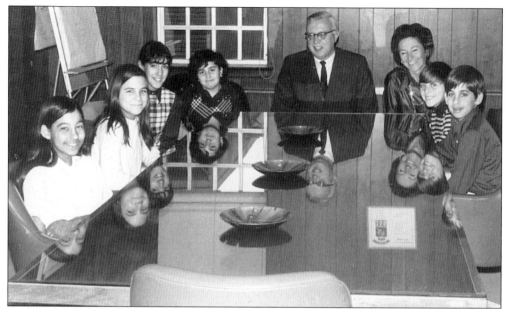

Manager Harp conducts a class for a group of elementary students and their teacher in the conference room at the town hall on February 5, 1970. The subject of this class was how to control pollution of the environment.

The Livingston Kiwanis Club conducts an annual carnival on Northfield Road, south of Livingston Avenue. This was the carnival in June 1961.

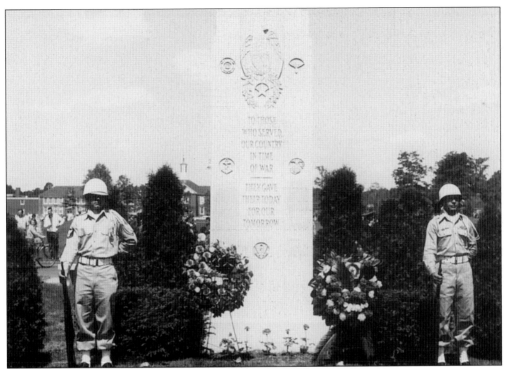

The Fourth of July celebration each year begins with a memorial ceremony on the mall (which is also frequently referred to as the "oval"). This photo was taken in 1961. The celebration has taken place since 1936. Hundreds of people turn out during the day, but the number grows to the thousands for the fireworks in the evening.

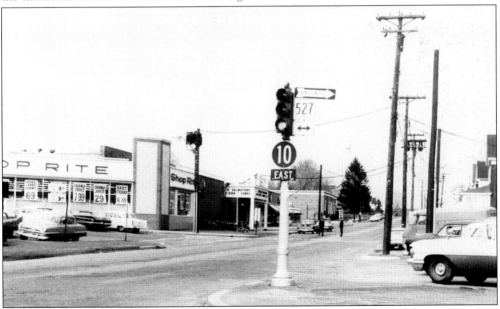

As the sign on the right indicates, Exxon was still called Esso in 1961, the year this picture of a portion of Livingston Center was taken. Note that orange juice was 29¢ a quart and canned ham was 69¢ a pound.

Who's that fellow conversing with Robert Peacock, a Livingston resident and chairman of the local Democratic Party, c. 1962?

This house at 223 E. Mt. Pleasant Avenue (pictured here in the winter of 1962) belonged to Andrew Teed, whose family was among the earliest settlers of Livingston. Andrew Teed was the sheriff of Essex County in the late 1850s. He was also the first clerk of the Livingston Baptist Church when it organized in 1850.

54

The Howell name was associated over the years with the teaching profession and the activities of the public library. This is the Howell homestead, which stood at the intersection of South Orange Avenue and Walnut Street. The house was removed in July 1964.

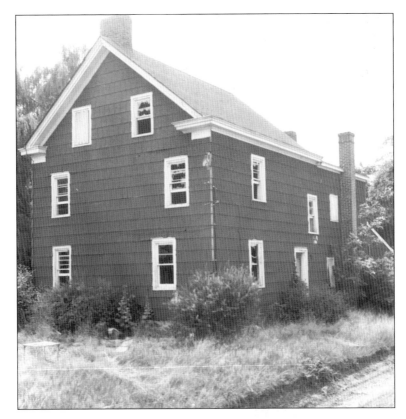

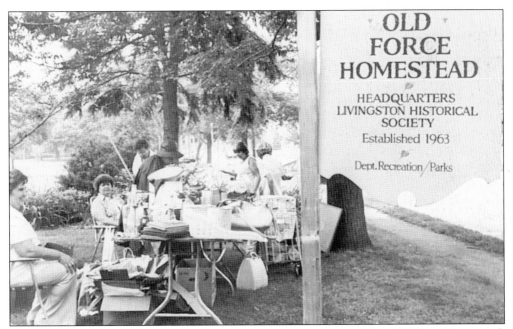

A significant part of volunteerism in Livingston is the operation of the Old Force Homestead. As the sign indicates, this site for the Livingston Historical Society was established in 1963.

The Small family was well known in Livingston. One of its members, Henry, who graduated from Livingston High School in 1965, was an outstanding athlete. He later became a football coach at Lehigh University.

Louis Bort, Esq. served with distinction as Livingston's township attorney from the early 1950s until 1975. He was recognized as one of New Jersey's foremost real estate experts of his time.

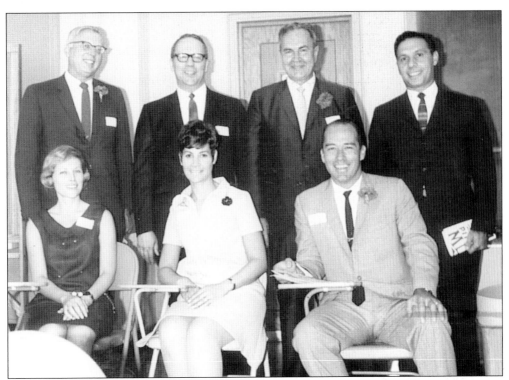

Manager Harp (standing on the left) meets with members of the Livingston Board of Education on September 12, 1969. Seated on the left is Mrs. Judy Zients, then-president of the board.

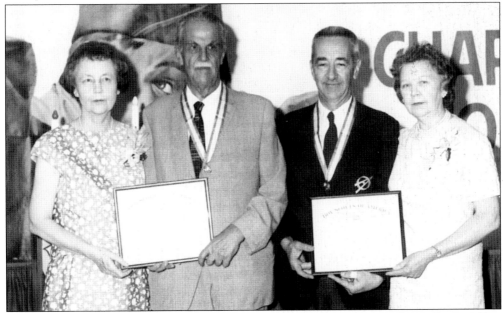

Congressman and Mrs. Robert Kean are shown on the left of this picture, taken in June 1966 at a Boy Scouts of America event. Congressman Kean, father of New Jersey's Governor Thomas H. Kean, was an avid supporter of the Boy Scouts. The Keans were early settlers of Livingston and are descendants of New Jersey's first governor, William Livingston.

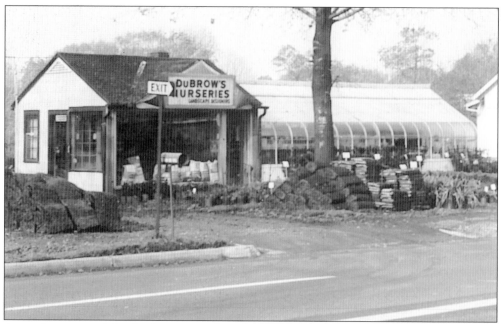

A good portion of the landscaping in Livingston was provided by DuBrow's Nurseries on Northfield Road. For many Livingstonites, the coming of spring portends an urgent meeting with Sheldon DuBrow for advice on matters horticultural.

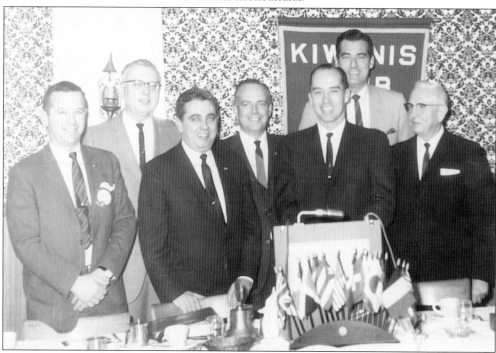

This picture is of a February 1968 meeting of the Kiwanis Club. The man partially blocking the Kiwanis banner is Dr. Kenneth Dollinger, a former mayor of Livingston and the father of another former mayor, Jeffrey Dollinger. On the left is Peter Cooper, a former mayor who is now a judge of the New Jersey Superior Court.

Arnold Eckhardt was a member of the Livingston Board of Education. He also owned Circle Nursery School, where many Livingston citizens spent their pre-school days.

The woman on the left is the former director of the Livingston Library, Ruth Rockwood, for whom the library is now named. The man next to Ruth is former Township Committee Chairman Joseph J. Spurr II. This photo was taken on June 27, 1967.

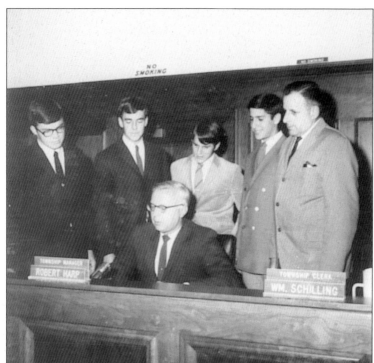

Manager Harp is shown meeting in the town hall with members of the Kiwanis-sponsored Key Club on October 24, 1968. The Key Club members provide various volunteer services to the community, including fund-raising activities for local charities.

Here is another illustration of Robert W. Kean's dedication to the Boy Scouts. He is pictured c. November 1969 with Wayne Bottlick (left) and James Eskin (right).

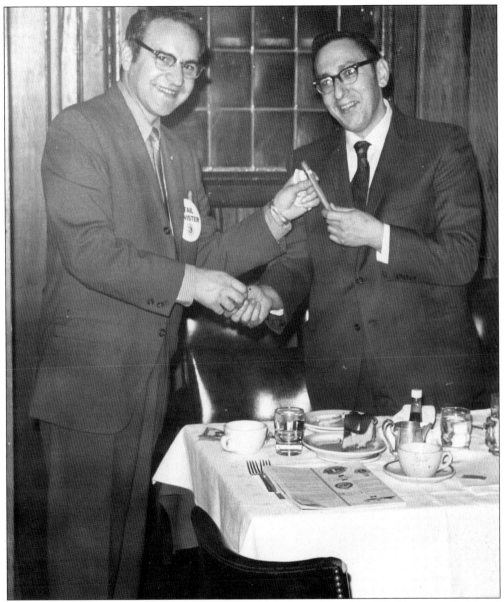

For many years, Livingston had two newspaper stores, one owned by Ed Silverman (left) and the other by Seymour Schram (right). "Silverman's" is in Livingston Center, and "Seymor's" is in Northfield Center. At each, people of the town would meet in the mornings, afternoons, and evenings, not only to purchase newspapers and the like, but also to discuss matters of the day and to renew acquaintances. These two men were competitors but also good friends.

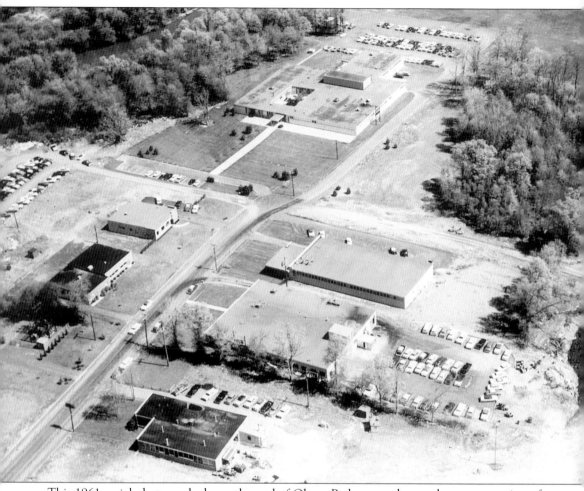

This 1961 aerial photograph shows the end of Okner Parkway at the northwestern portion of Livingston, known as Industrial Park. For a number of years, *Newsweek* magazine had production offices in this section of town, as did a number of light manufacturing facilities.

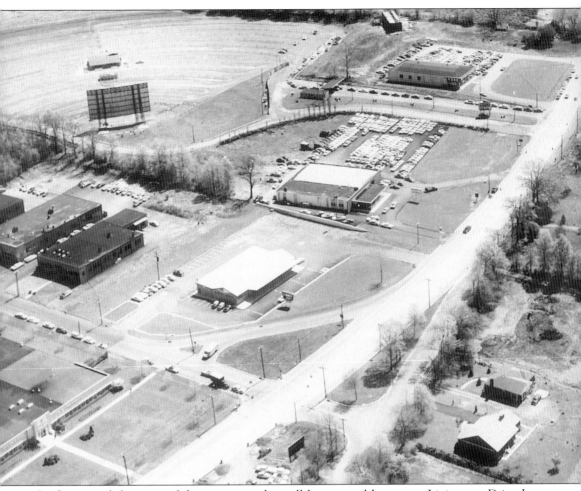

In the upper left corner of this picture is the well-known and long-gone Livingston Drive-In Theater, where so many people went to watch movies . . . supposedly.

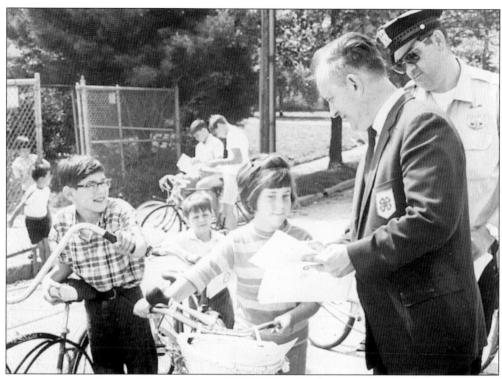

These young 4-H Club members are performing their duties under the watchful eyes of an advisor. The Livingston police officer probably is there to make sure that the children's bicycles are in safe working order.

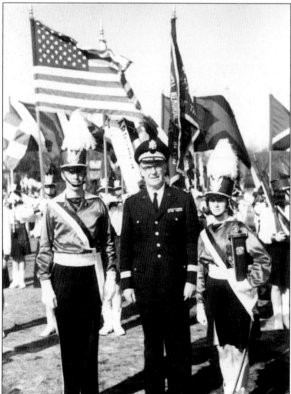

The Imperial Guardsmen of Livingston's Drum and Bugle Corps pose for a photograph, c. April 1968. This group (no longer in existence) performed at many outdoor events in the town, especially the Fourth of July celebration. It was sponsored by the Livingston Baptist Church; the Roseland-Caldwell Memorial Post 2619, Veterans of Foreign Wars; St. Raphael's Roman Catholic Church; South Orange American Legion, Post 220; and the Livingston Department of Recreation and Parks.

One of Livingston's best-known educators, Dr. John Rowley, was the principal of Heritage Junior High. This picture of Dr. Rowley was taken in 1970.

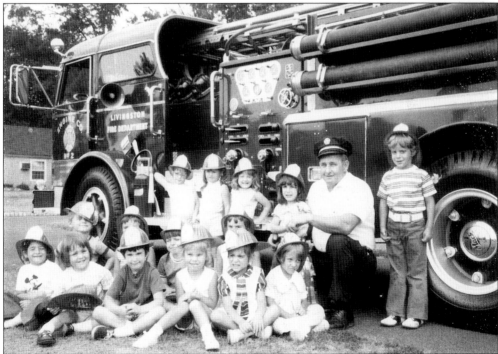

The word "beloved" is probably overused in books like this. But it is unlikely that anyone would dispute its aptness in describing Livingston's former fire chief, Charlie Schilling, shown here in July 1971 with possible future members of his department.

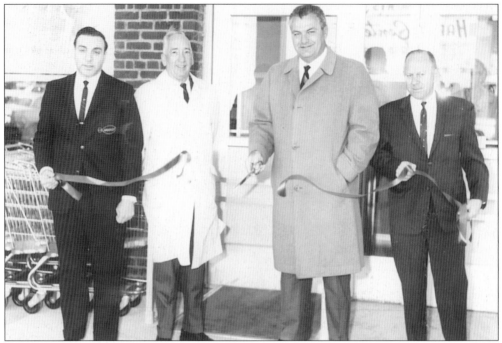

Mayor John Duetsch (with the scissors) performs a traditional mayoral function, the dedication of a new store. When he was not serving as mayor, Jack Duetsch was the managing partner of a prominent New York City law firm.

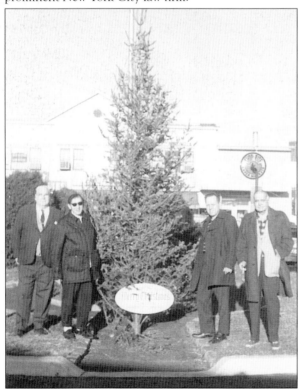

Members of the Livingston Chamber of Commerce are shown here presenting a Christmas tree for display in Lions Park, c. 1971.

Father Edward Kavin looks over a January 1968 fund-raising event conducted by the parishioners of St. Philomena's Church. At this meeting, $250,000 in pre-campaign pledges toward a million-dollar drive was announced. The photograph was taken in the gymnasium of St. Philomena's. A little-known fact is that the first Catholic Mass in Livingston was conducted in the Force Home on S. Livingston Avenue.

Ely Tavern on W. Mt. Pleasant Avenue (see p. 23) is brought to an inglorious end on November 30, 1967.

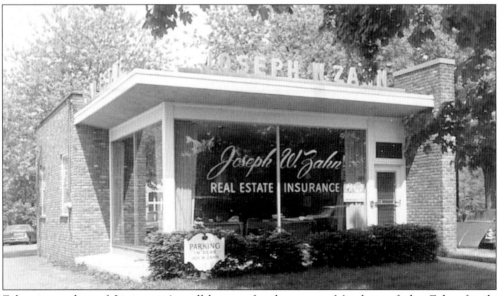

Zahn is another of Livingston's well-known family names. Members of the Zahn family were active in municipal government. Joseph W. Zahn's real estate company is located on S. Livingston Avenue.

Ruth Rockwood, shown here in the mid-1970s in her office at the library, served as the library director from 1957 to 1980.

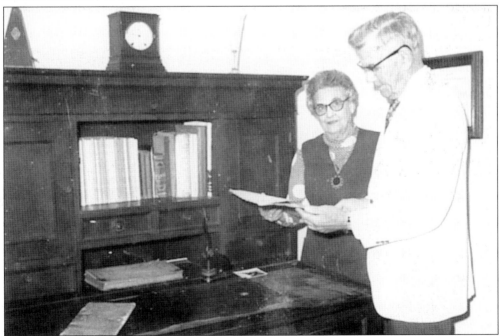

Bertha and Richard Swain were photographed at a meeting of the Livingston Women's Club in the early 1970s. Richard Swain was Livingston's police chief for almost 40 years, before retiring in 1969.

In February 1974, Danny Pallone and Mary Beth Picini were in Mrs. Harting's fourth grade class at the Hillside School, one of Livingston's elementary schools.

Abba Eban, a former Israeli Minister of Foreign Affairs, was a guest speaker at Temple Beth Shalom on Mt. Pleasant Avenue in October 1974.

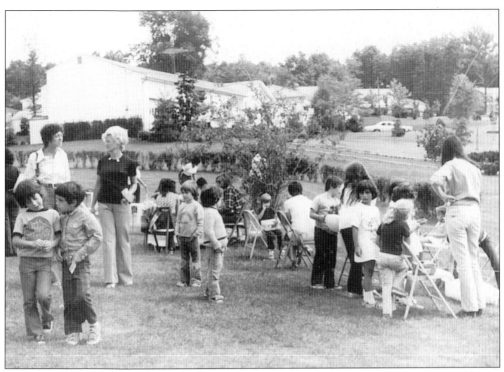

This carnival took place in October 1974 at the home of Mr. and Mrs. Harvey Belfer on Stoneham Drive to raise funds to fight cystic fibrosis.

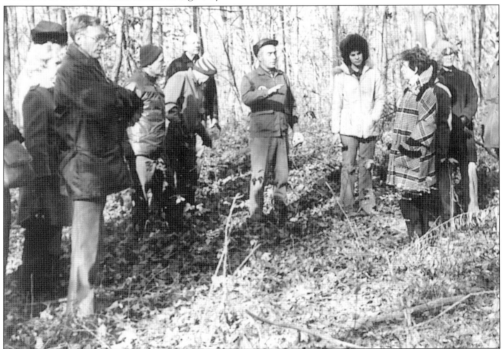

Mayor Robert Leopold takes part in a November 1974 conservation council meeting in an area of town to the east of Shrewsbury Drive.

C. George Dahl was the post commander of American Legion Livingston Post 201 in 1965. He is shown here on July 2, 1970.

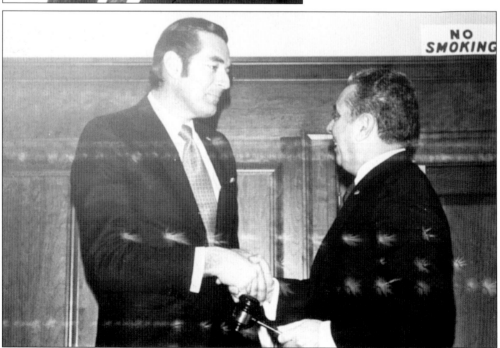

Councilman Dollinger is seen here shaking hands with Councilman Kenneth Welch at the council's first meeting in 1970. The members of the township council have equal authority; however, each year one of the members is designated to serve as mayor.

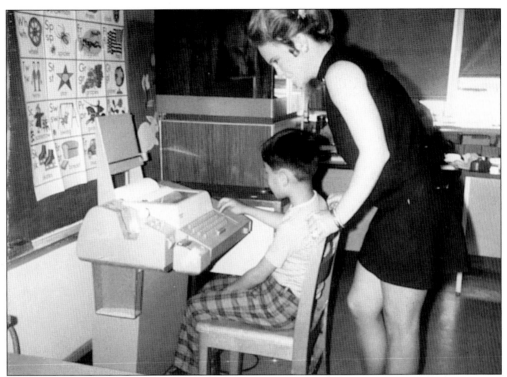

Harrison schoolteacher Carol Wheatley is seen here assisting a student, Robert Kang, in June 1971. Mrs. Wheatley began teaching in 1957 and retired in 1991.

Bible school assistants at the Livingston Presbyterian Church pose for a photograph in May 1971.

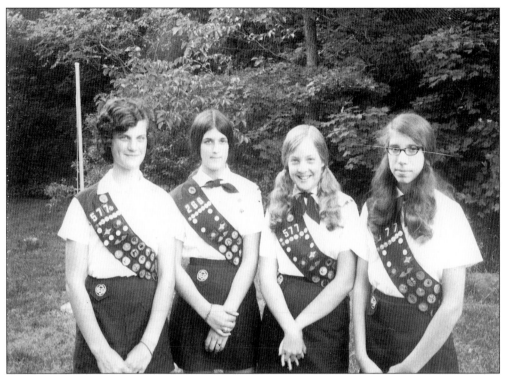

Four of Livingston's Girl Scouts are shown here at a meeting on June 15, 1972. From left to right are Terri Byrnes, Theresa Groome, Diane Armor, and Marjorie Olmstead.

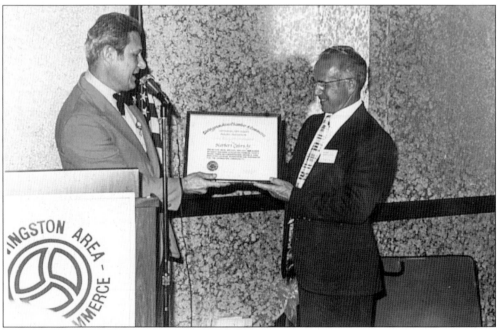

At the Livingston Chamber of Commerce meeting in May 1979, Herbert Cohrs Jr., Livingston's postmaster, is presented with a plaque commemorating his 37 years of service in that position.

Four

TODAY AND THE FUTURE

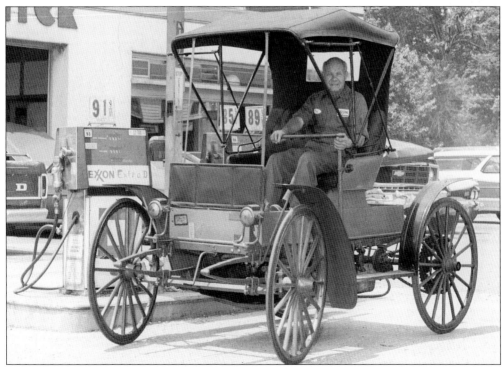

Teddy Panek's automotive garage was another of the favorite meeting places of Livingstonites over the years. Teddy was a decorated war hero and a great athlete. He is shown here waiting to fill up his 1900 Sears, which was the first car in Livingston. It got 80 miles to the gallon and had a 2-cylinder, 15-horsepower engine.

This building originally was Olivet Chapel and was used by the Masonic Lodge. It is on W. Mt. Pleasant Avenue and remains the home of the Masonic Lodge.

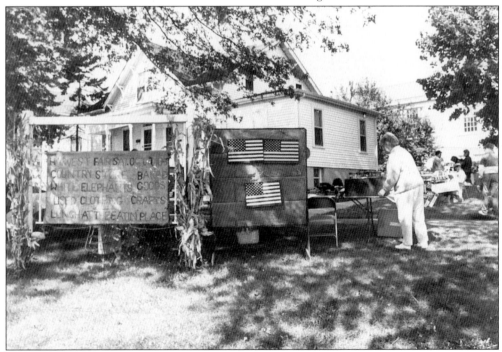

The Federated Church of Livingston on W. Mt. Pleasant Avenue has a harvest fair in October of each year. This picture of the fair was taken in 1989.

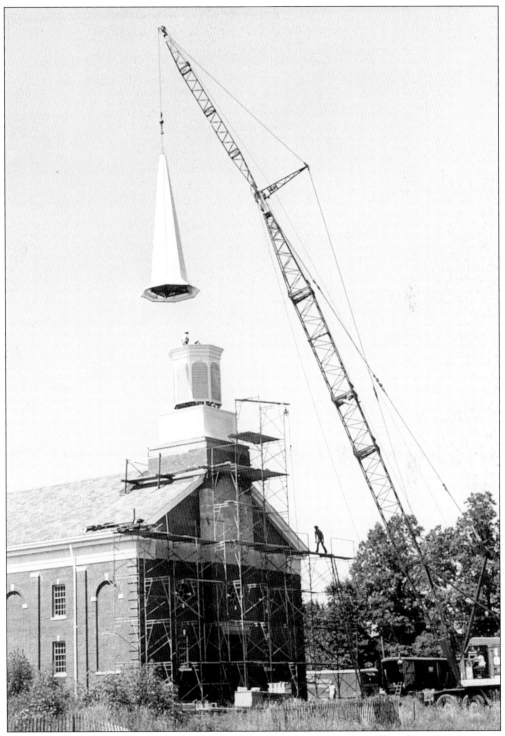

On August 4, 1972, the steeple was placed on the new St. Philomena's Church on S. Livingston Avenue.

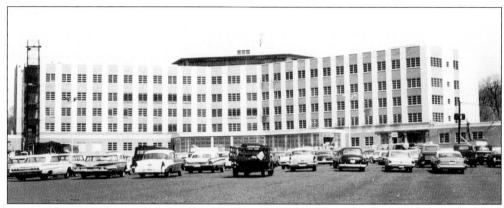

St. Barnabas Hospital nears completion in May 1964.

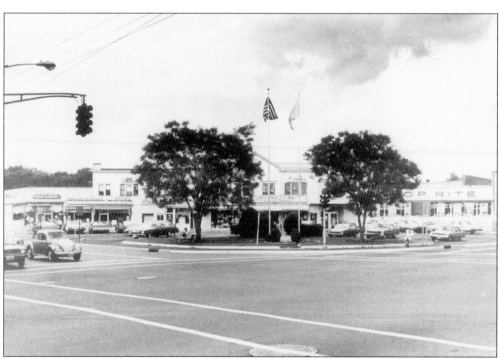

Lions Park is in the foreground of this June 1976 photograph. The Plaza at Livingston Center is visible in the background.

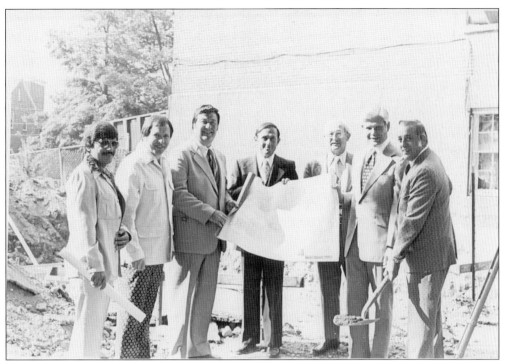

In July 1976, the former Roosevelt School became Roosevelt Plaza. Here is the ground-breaking ceremony for the latter. From left to right are Robert Ring (architect), Joel Shenman, Larry Stern, Howard Perley, Morris Hammer, and Mel Gebroe. On the right with the shovel is Mayor Dominick Crincoli.

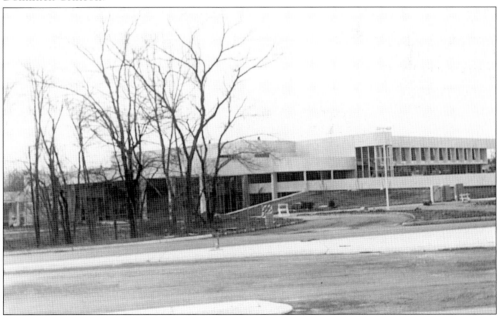

No longer in existence, the Howard Savings Bank was once one of New Jersey's most active savings institutions. It is shown here under construction on South Orange Avenue, in Livingston, *c.* 1978.

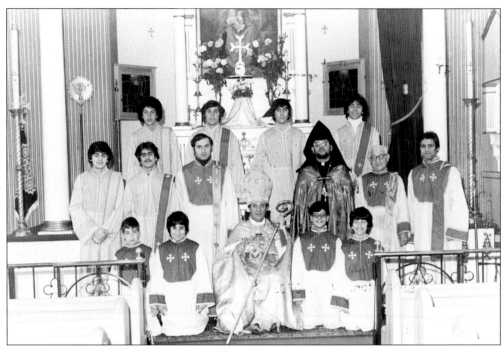

This picture was taken at St. Mary's Armenian Church, W. Mt. Pleasant Avenue.

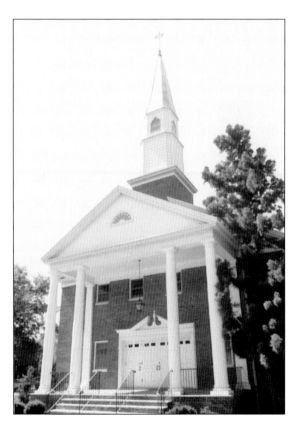

The Presbyterian church is on W. Northfield Road. Shown here c. 1990, it was established in Livingston in 1950.

This picture, taken in June 1980, is of Charles DeMarco (on the right). At the time of his death, Chuck was engaged in writing what would have been the modern-day history of Livingston.

Yale Apter was Livingston's municipal judge in the late 1970s. He left the local bench to become a Superior Court judge in Essex County. Now gone from our midst, he is remembered by all who knew him as a person possessed of equal quantities of wisdom, fairness, and kindness.

Livingston's first woman mayor, Doris Beck, throws out the first ball at a softball game between West Essex General Hospital and the doctors of St. Barnabas, *c.* 1975.

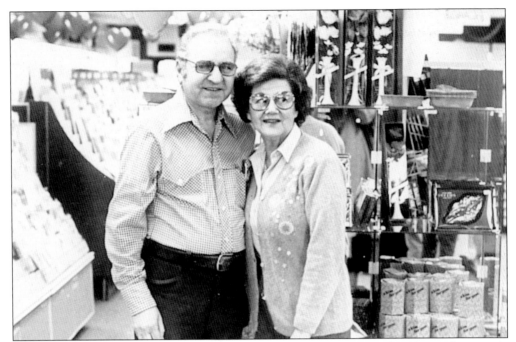

Mr. and Mrs. Edward Silverman stand in their shop, Silverman's, in the Plaza in Livingston Center. Typically, Silverman's was the place where schoolchildren got their supplies as they headed off in September for another year's endeavors.

Livingston's religious leaders gathered to sign a proclamation urging an end to nuclear proliferation, c. 1982.

Mayor Doris Beck presents a plaque to retiring Councilman C. David Geer in June 1972.

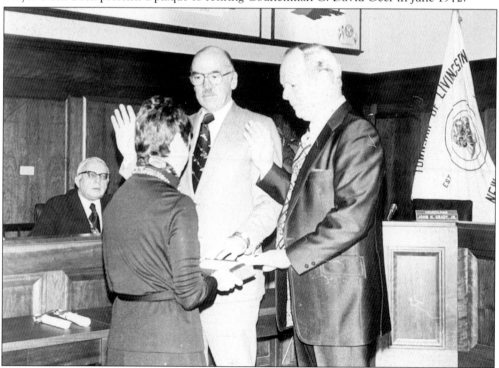

In January 1977, Township Clerk Renee Green administers the oath of office to council members John Grady (left) and John Collins (right). Looking on is Township Manager Harp.

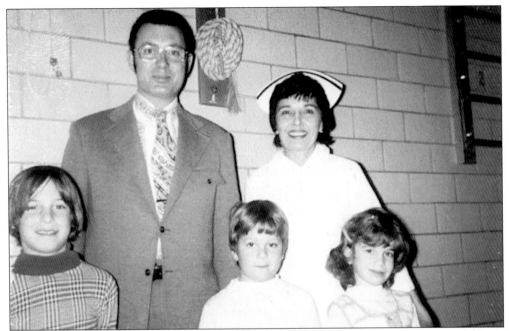

It was "Dental Health Week" at Harrison School in February 1974. Pictured here are dentist Ronald Hausman, school nurse Phyllis Swain Kowalchuk (her father was Richard Swain, Livingston's police chief), and students Robert Axel (left), David Endres, and Jennifer Campus (right).

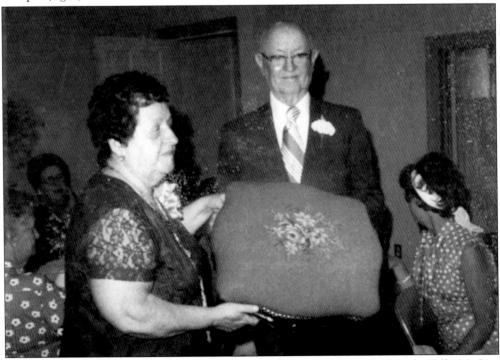

Reverend Ray McCoy of the Northfield Baptist Church and his wife, Myrtle Tully McCoy, celebrated their 50th wedding anniversary in August 1974.

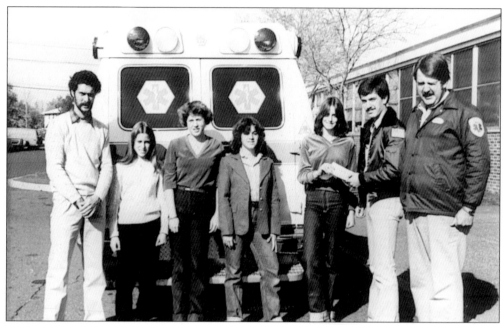

The 1980–81 officers of Mt. Pleasant Jr. High School present two members of the Livingston First Aid Squad with a check in memory of Raymond Bradbury, a custodian at the school who was for years a favorite of the students. The students are, from left to right, secretary Debra Browde, vice-president Virginia VanNest, treasurer Helaine Harte, and president Lori Evenchick (daughter of the author).

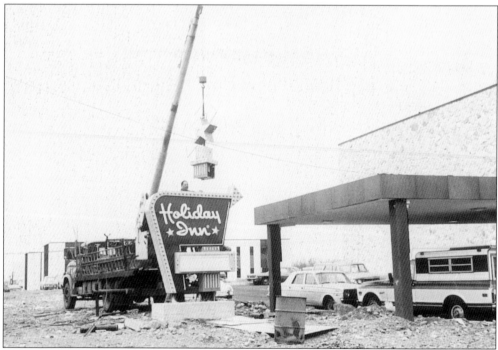

The Holiday Inn on Route 10 is shown here under construction in March 1973. The building is still used as a hotel, although Holiday Inn no longer owns or operates it.

This building was the main post office on S. Livingston Avenue. There is a small satellite office of the post office on Northfield Road. Through the efforts of the late Congressman Dean Gallo, a new main post office building was constructed on Mt. Pleasant Avenue, west of S. Livingston Avenue, several years after this photo was taken.

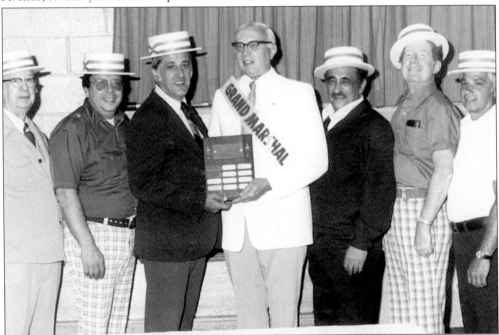

Township Manager Harp was grand marshal of the Memorial Day parade in 1977. Here he is being presented with a plaque commemorating his exalted position by Mayor Crincoli and other members of the parade committee.

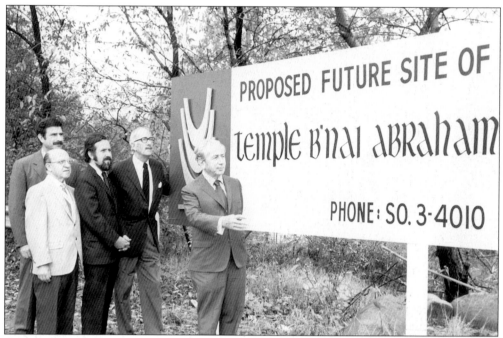

Rabbi Joachim Prinz, spiritual leader of Temple B'nai Abraham, and members of the temple's building committee stand on land immediately to the south of Northfield Road, where the new edifice soon became a reality.

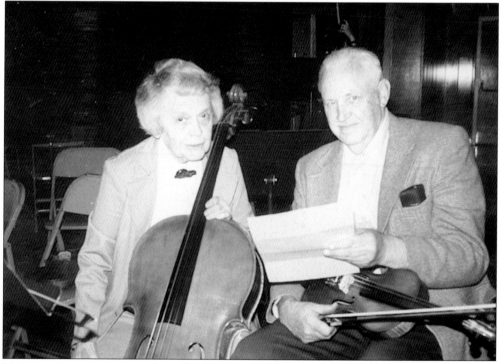

Livingston's community symphony has been in existence for almost 30 years. Here in May 1980 are cellist Ada Kambour and violinist Robert Spohn.

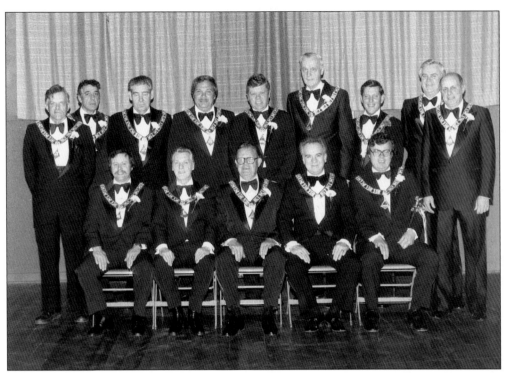

These are the members of the Livingston Elks Club in May 1980. The building housing the Elks Club is located on W. Mt. Pleasant Avenue, about one block west of the Starbucks Coffee Shop, and has the letters "BPOE" (for "Benevolent Fraternal Order of Elk") on the roof.

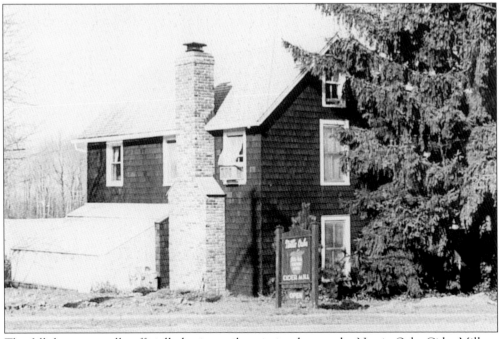

The fall does not really officially begin until a trip is taken to the Nettie Ochs Cider Mill on Old Short Hills Road. The Ochs family has operated this cider mill for several generations.

In January 1982, Charles J. Tahaney was township manager of Montville, New Jersey. In this photograph, Chuck is announcing that Robert Harp has been named as the recipient of the New Jersey Municipal Managers Association Career Award.

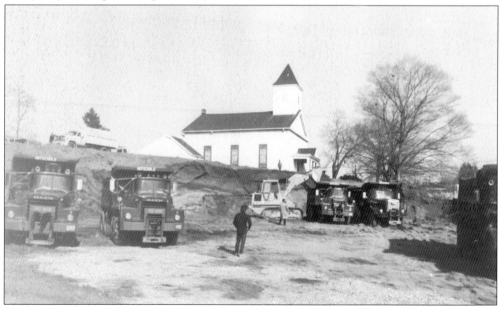

Here is the start of the construction of Broad National Bank on W. Mt. Pleasant Avenue, c. 1986. The bank, which was chartered in 1925 and headquartered in Newark, had chosen Livingston as one of its early Essex County locations outside of Newark.

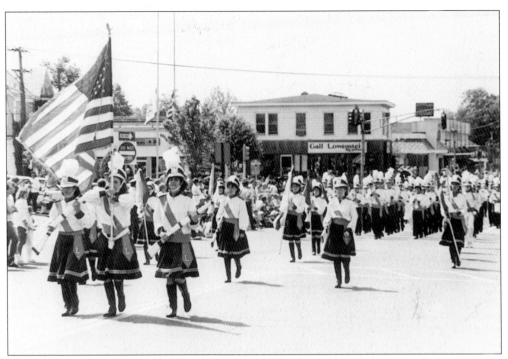

The people in the foreground of the 1986 Memorial Day Parade are about to reach the reviewing stand on the east side of N. Livingston Avenue.

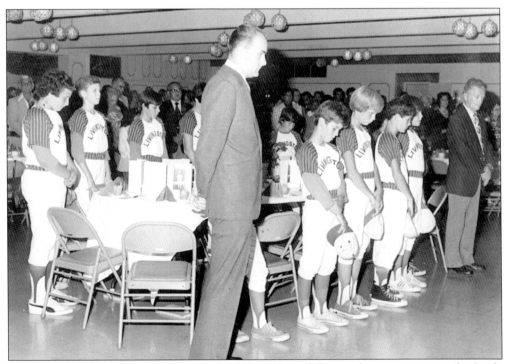

Livingston Little Leaguers stand with their heads bowed during the invocation at the Little League banquet in September 1974.

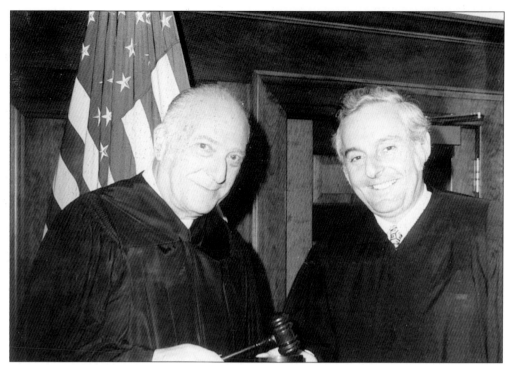

On the occasion of Judge Yale Apter's elevation to the Superior Court, he turns over the gavel to new municipal court judge Irving Vichness. Several years ago, Judge Vichness's son Paul became a judge of the Superior Court of New Jersey.

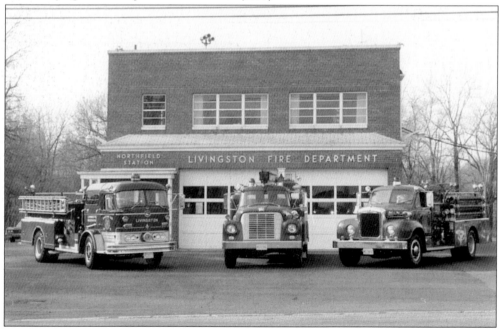

The Livingston Fire Department's Northfield Station is shown in this 1980 photograph. The station, built in the 1950s, serves primarily the southeastern and southwestern portions of the community.

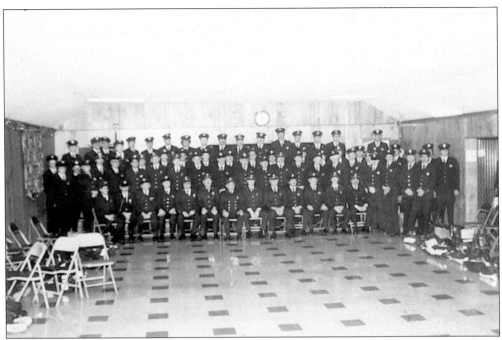

This picture brings a new meaning to the expression "taking a back seat," but the Livingston Volunteer Fire Department need not take a back seat to anyone. Except for the chief, who is paid, everyone else is a volunteer. The department has a reputation for being one of the finest in the state.

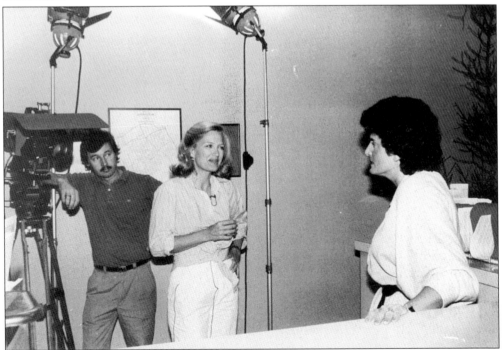

Television newswoman Diane Sawyer interviews Mayor Shari Weiner for a program on overcoming the drug menace, August 1986.

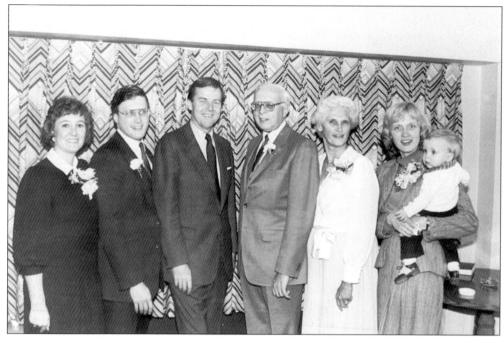

Township Manager Harp and Mrs. Harp, Governor Kean, and members of the Harp family are shown here during a retirement dinner for Robert Harp on October 10, 1985. He served as township manager from 1957 until 1985.

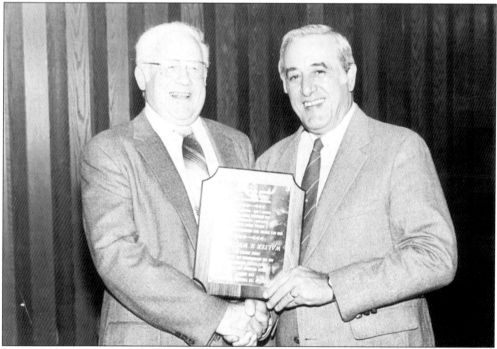

On November 30, 1984, Walter Whiteman retired as the municipal court clerk, having served for many years in that capacity. We might know precisely how many years if Mayor Crincoli had held the plaque rightside up for the picture!

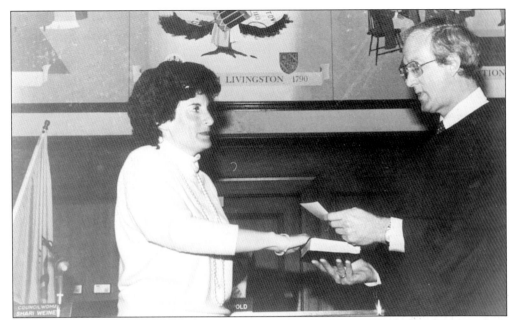

Shari Weiner is shown here being sworn in as mayor by Municipal Court Judge Martin J. Brenner in January 1986. The mayor really has no powers different from the other members of the township council. Each year the council chooses one of the members as mayor, and that person traditionally performs ceremonial duties as the spokesperson for the council.

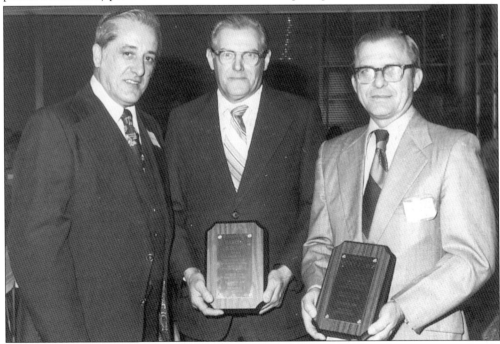

It has been a long-standing tradition in Livingston to have an annual appreciation dinner during which the many volunteers in the town, as well as town workers, are recognized for their efforts. In this photograph Mayor Crincoli is presenting plaques for 25 years of service to Harold Liebenow (center) and Henry Nycz (right).

Henry Nycz was the planning director of the township. He served for many years in that capacity and retired in 1988.

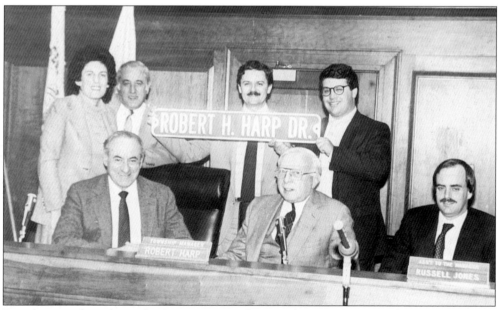

For what may have been the first time in its history, the township named a street in honor of one of its own. Standing and displaying the new street sign for "Robert H. Harp Dr." are, from left to right, Councilwoman Shari Weiner and Councilmen Dominick Crincoli, Thomas Adams, and David Wildstein. Seated are Councilman Robert Leopold, Robert Harp, and Deputy Manager Russ Jones. Robert H. Harp Drive is located in front of the high school.

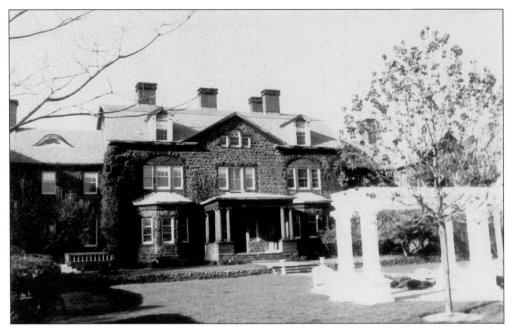

This is the mansion on what had been the Kean estate. It was developed and owned by Congressman and Mrs. Robert H. Kean, parents of New Jersey Governor Tom Kean. After Congressman Kean's death in 1980, the estate was sold, and one-family homes were built on the land. The mansion has been preserved, although it is no longer used as a residence.

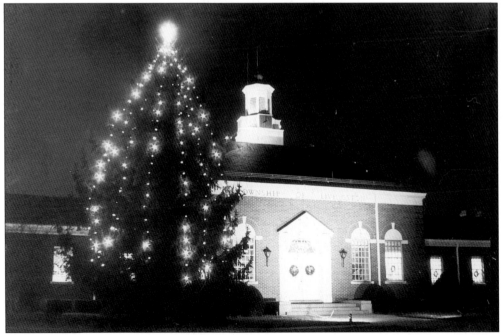

The town hall is shown here at night during the Christmas season of 1983. The clock on the cupola is a gift of Swiss industrialist Hans Oetiker, whose business is located on Okner Parkway. He presented the clock as a token of his esteem for the United States and the Township of Livingston.

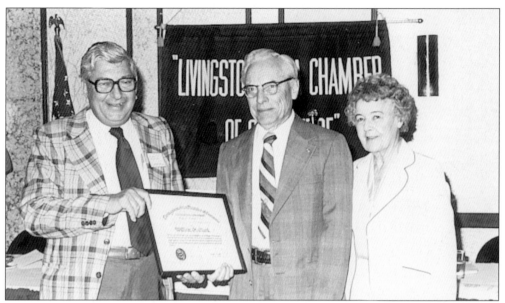

William Klaber Jr., the former editor of the *West Essex Tribune*, presents a certificate of thanks and recognition on behalf of the Livingston-Area Chamber of Commerce to William H. Clark. He probably still holds the record for having held more governmental positions in the Township of Livingston than any other person. Appointed to the planning board in 1938, he served for many years on that body and was elected to the township committee in 1950. He is unquestionably the person, more than any other, who is responsible for the planning and design of modern-day Livingston.

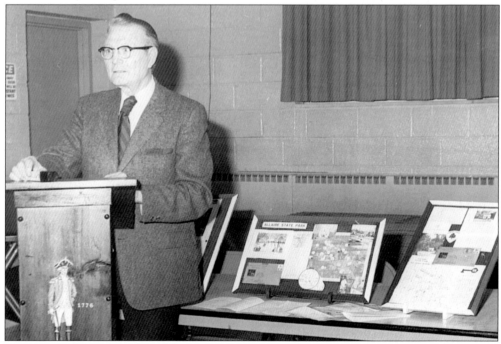

Maurice Hopkins, a member of the Livingston Historical Society and an expert on New Jersey history, presents a lecture on Allaire State Park, *c.* 1973.

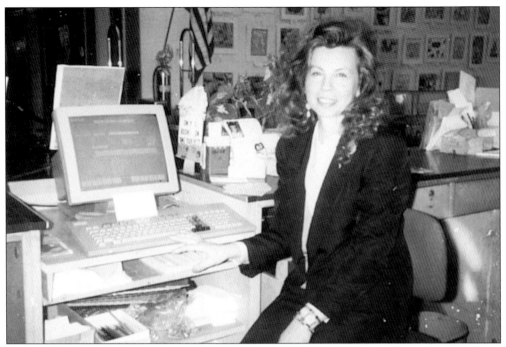

This is Barbara Sikora, director of the Ruth Rockwood Memorial Library. There are a handful of people who are walking encyclopedias of Livingston's history; Barbara is one of them.

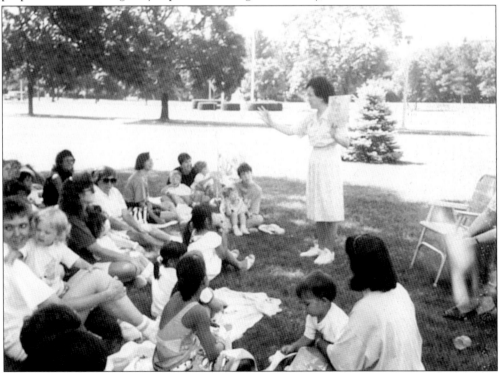

Grace Chen of the Livingston Library staff captivates an audience on the lawn outside the library, c. 1991.

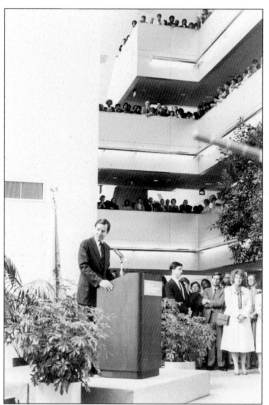

Governor Kean speaks at the dedication of the Bellcore Building in July 1985. The imposing structure is still there, but Bellcore has since moved to a new location. The building is now a general office building on Route 10 at the circle.

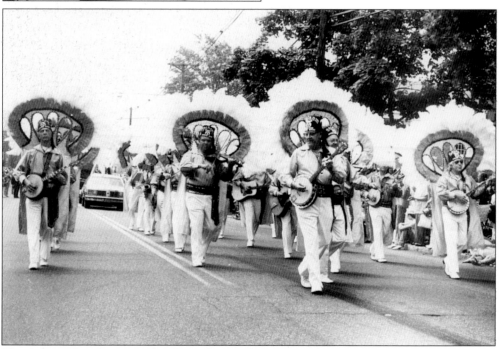

The Salaam Temple's string band marches in the Memorial Day parade in 1978. The band's appearance is always one of the eagerly awaited events of the parade.

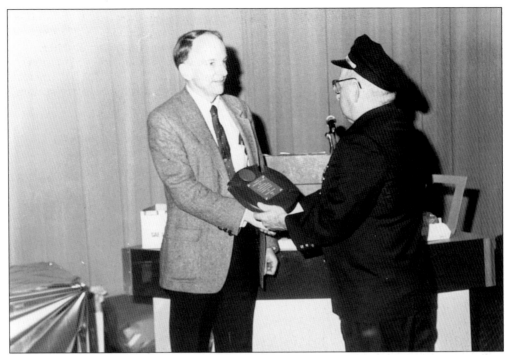

E. Christopher Cone, editor of the *West Essex Tribune*, is about to receive an award from Fire Chief Charles Schilling. Cone has a reputation for representing the newspaper's editorial positions with reason and objectivity.

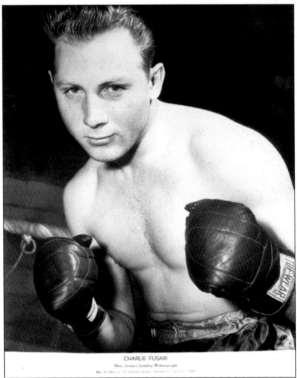

CHARLIE FUSARI
New Jersey's Leading Welterweight

Livingston has produced a number of notable sports figures. Charlie Fusari, a leading welterweight fighter, is shown here. His son Mark is active in local politics.

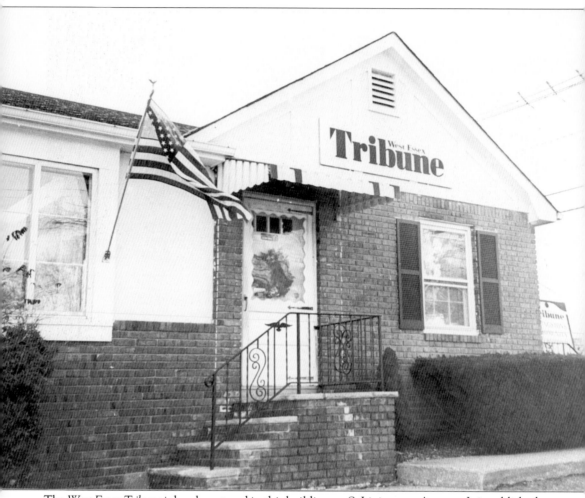

The *West Essex Tribune* is headquartered in this building on S. Livingston Avenue. It is published every Thursday. It is not unusual to see people lining up to get an advance look at the paper when it is delivered to several local stores on Wednesday evenings.

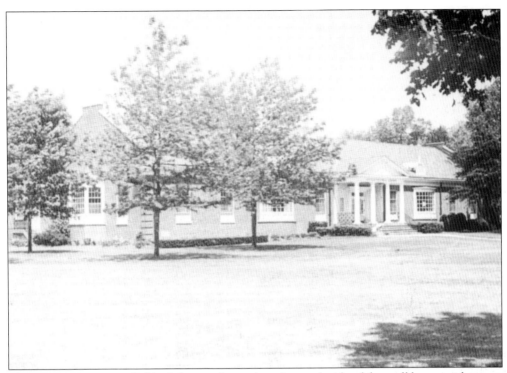

The present Livingston Public Library is located on the north side of the mall between the town hall and the high school.

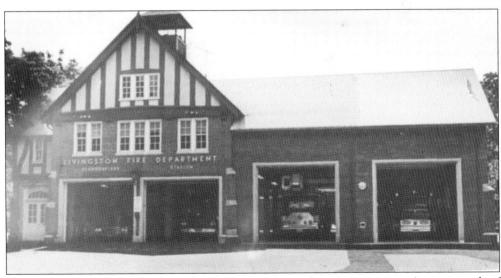

The Livingston Fire Department's headquarters is located on S. Livingston Avenue, south of Mt. Pleasant Avenue.

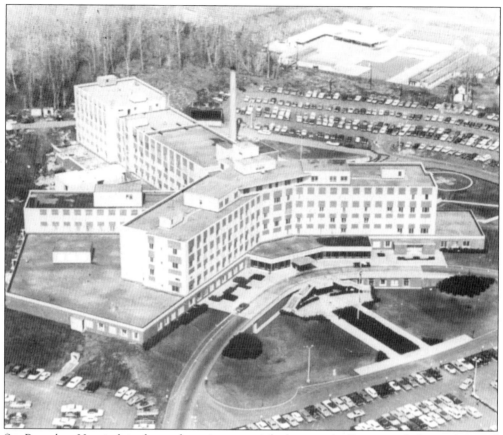

St. Barnabas Hospital is shown here in an aerial photograph. Because of the quality and competence of its staff and the vast scope of its facilities, the hospital has gained the respect and admiration of the medical community.

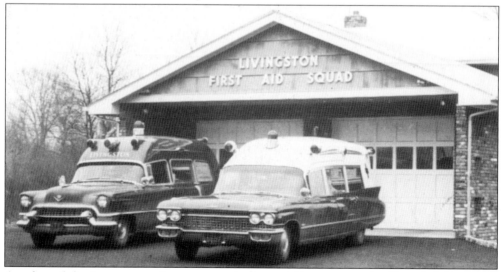

Another of the important volunteer organizations in Livingston is the First Aid Squad. Its location has changed over the years, but the dedication of its members has remained constant.

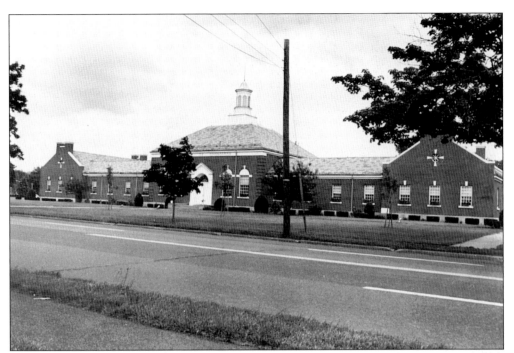

This is the present town hall, located on S. Livingston Avenue. The council chambers, which also serve as the municipal court, are in the center section of the building. Other municipal offices are in the north and south wings.

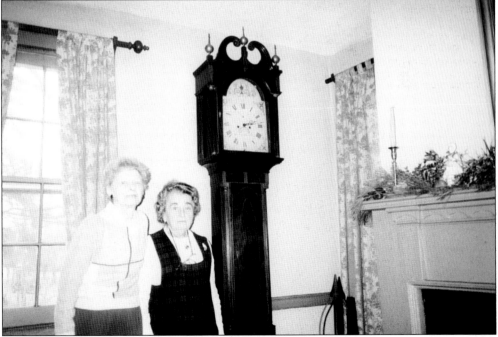

Livingston Historical Society members Helen Shumsky (left) and Carol Huck (right) stand next to the grandfather clock inside the Force Home. The clock once belonged to Thomas Alva Edison. Helen and Carol serve as docents for the Force Home.

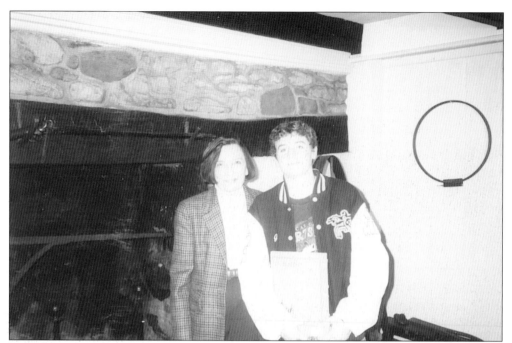

Phyllis Swain Kowalchuk of the Livingston Historical Society and Joseph McBride, a sophomore at Livingston High School, stand next to the old fireplace in the Force Home. McBride was there to do research for a term paper.

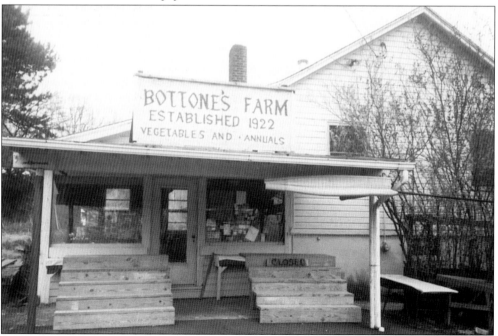

This photo, taken in December 1998, shows Bottone's Farm on Beaufort Avenue. As the sign says, the farm was established in 1922 and still actively sells vegetables and annuals to the public. The "closed" sign on the steps means only that business has come to a halt for the winter season.

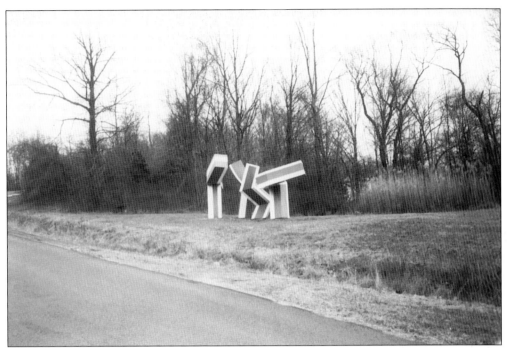

This is a sculpture that marks the entrance to Riker Hill Art Park off of Beaufort Avenue. The land is owned by the County of Essex, and artists' studios are leased in buildings located on the grounds for such activities as steel sculpture, glass blowing, pottery, photography, and painting.

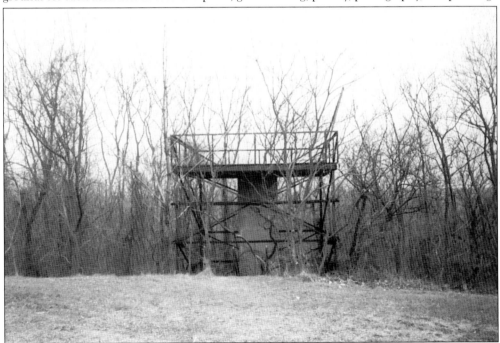

Riker Hill Park was once the site of a nike missile base operated by the New Jersey Department of Defense. This photograph shows an old silo used for storage of missiles. There are ongoing discussions as to what future use to make of this land.

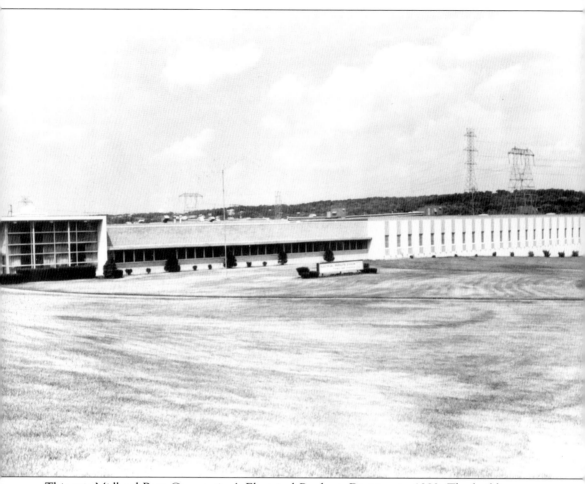

This was Midland Ross Corporation's Electrical Products Division in 1982. The building was on almost 9 acres of land in the southeastern portion of the industrial section of Livingston. Several years ago, this building and a number of other properties in the industrial section were vacant, prompting the municipal planning board to make recommendations for changes in the zoning plan to allow retail business use of the area.

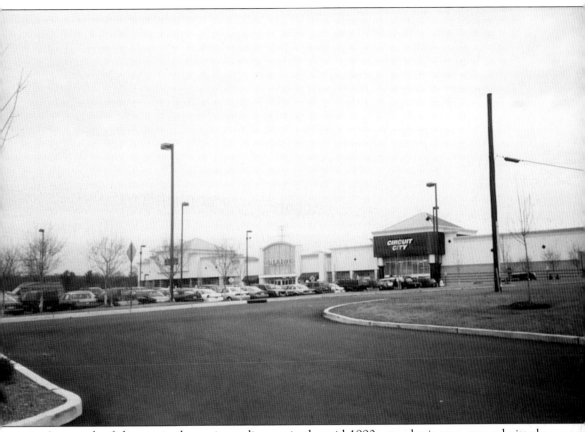

As a result of changes in the zoning ordinance in the mid-1990s, new businesses were admitted into what had been the industrial zone. This picture shows the area formerly occupied by Midland Ross Corporation. Their building was razed and replaced by what is seen here, a building that houses several major retail stores. The developer of this property also built a jughandle along Route 10, which allows eastbound traffic on that highway to turn left into this area.

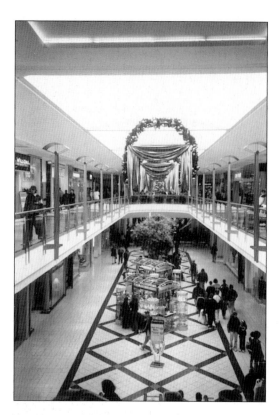

In the late 1960s and early 1970s, consideration began to be given to allowing a major shopping center to be developed in Livingston. The result was the Livingston Mall, shown here in 1998.

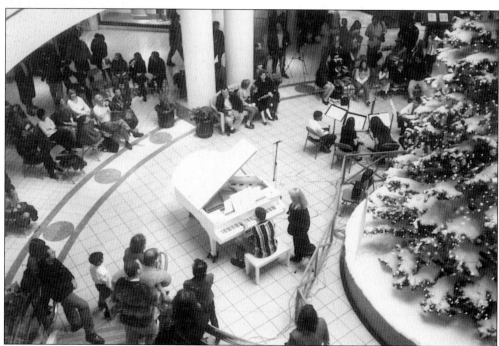

This is another view of the Livingston Mall. A concert is being performed by members of a special school for the learning impaired. An appreciative crowd listens as a young pianist performs.

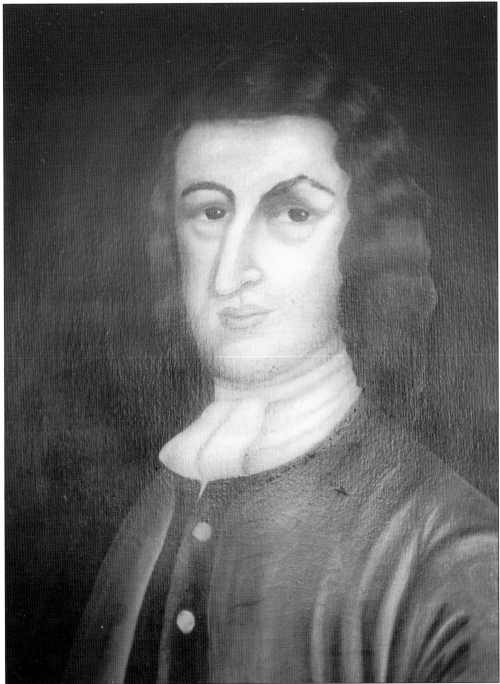

This painting of New Jersey's first governor, William Livingston, is by Bertha Swain, wife of former Livingston Police Chief Richard Swain. It hangs in the Force Home on S. Livingston Avenue. Livingston was a signer of the Declaration of Independence and a commander of New Jersey militia. He served as governor for 13 terms and signed the United States Constitution. He died on July 25, 1790, and was buried in Prockholst, NY, 23 years before Livingston chose his name as its own.

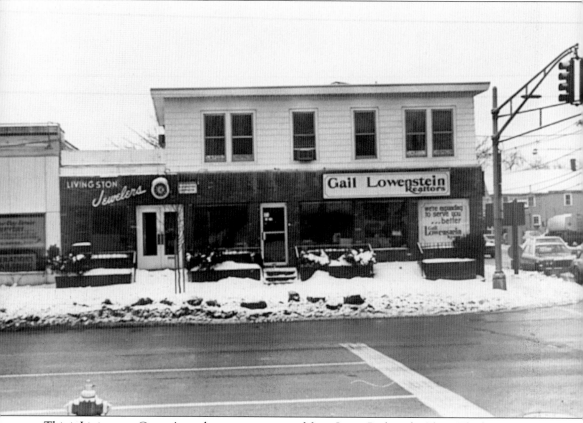

This is Livingston Center's southeast corner viewed from Lions Park at the Plaza. The businesses, as can be seen from this picture, have been there for many years. For reasons that probably relate uniquely to the personality of Livingston, these retail businesses remain, notwithstanding the mall and the advent of big box stores.

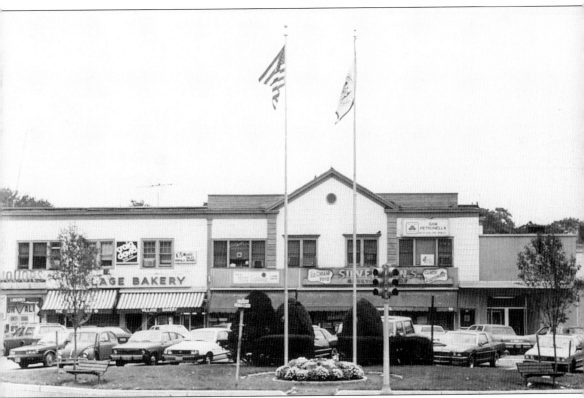

Despite the emphasis upon preserving small businesses in town, some of those shown in this photograph of the Center about 13 years ago are no longer there. Because the owner of the property has not decided what to do with it in the future, some of the tenants have found other places to carry on their businesses. Through it all, the character of this section of Livingston remains substantially the same as it has been for the past three decades.

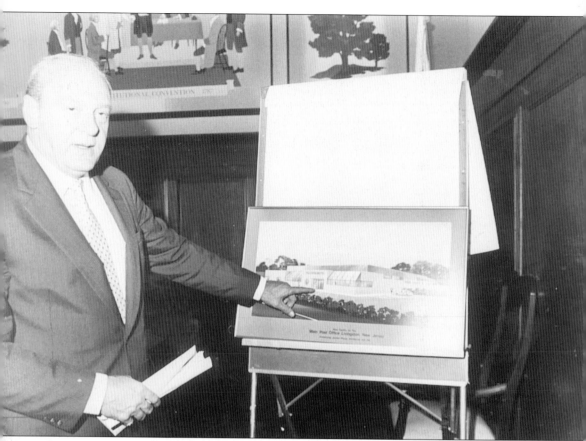

Congressman Dean Gallo was a strong and eloquent voice in the House of Representatives for his Livingston constituents. Livingston might still be fighting for a new post office were it not for him. By 1986, he had achieved his objective and is pictured here at the town hall showing what the new post office would look like. Today the post office exists as depicted in the sketch.

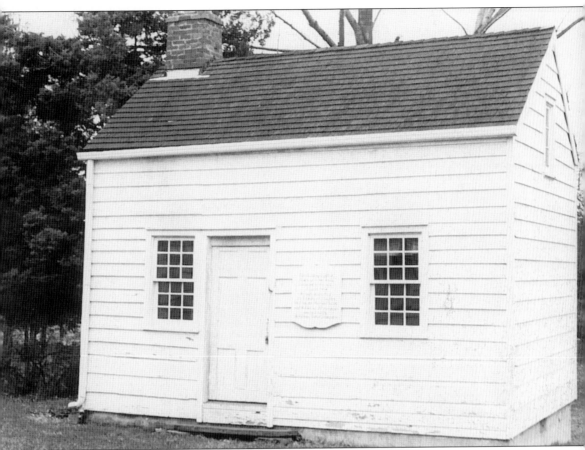

This is a perfectly preserved outbuilding that is now located alongside the Force Home on S. Livingston Avenue. For many years it stood almost by itself on the western side of the town where the Livingston Mall is now located. In 1964, as a gift from Bamberger's Department Store, the building was moved to its present location through the joint efforts of the Livingston Historical Society and the Kiwanis Club.

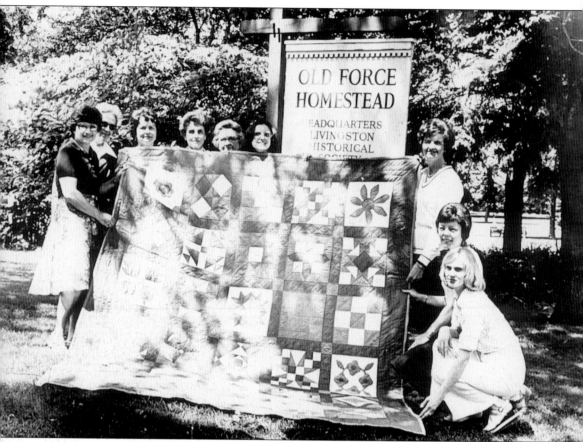

The women pictured here made this beautiful quilt in honor of the nation's bicentennial and presented it to the Livingston Historical Society. Shown from left to right are Judy Wahler, Edith Zang, Sara Mitter, Irene Nakonechny, Bertha Swain, Midge Perry, Louise Fuber, Linda Browner, and Barbara Schaeffer.

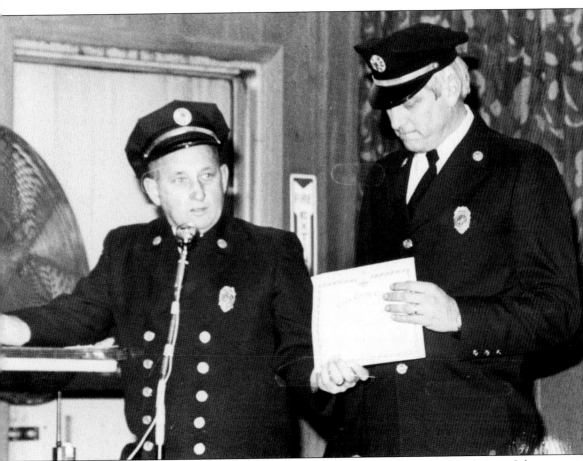

Charlie Schilling had not yet retired as fire chief when he presented an award to fireman John Durish. Charlie served for many years not only as the fire chief but also as the head of the First Aid Squad. He was the toastmaster at most major township events and was a genuine friend of all who called Livingston their home. While he is retired, Charlie seems as busy as ever with his volunteer efforts throughout the community.

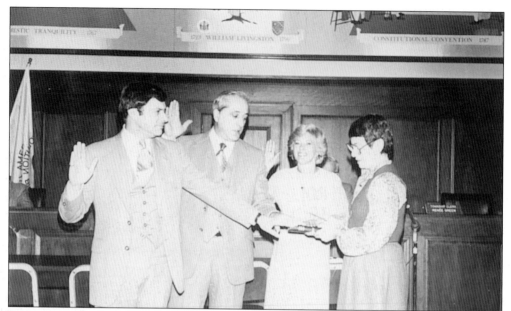

January 1 is Organization Day in the town hall. That is when the council members are sworn in and give their New Year addresses to the public. In this picture, Township Clerk Green is swearing in Councilman Steve Geffner (left), Councilman Dominick Crincoli, and Councilwoman Doris Beck. Councilman Crincoli is one of the best third baseman ever to have served in the annual town hall vs. the firemen softball game held on the Fourth of July.

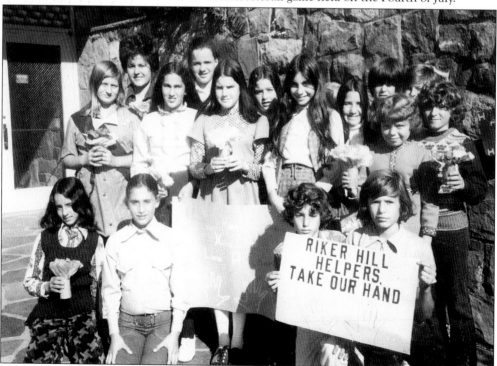

The concept of helping others is ingrained in Livingston's youth early on. Here are students at the Riker Hill School offering to be helpers in the project of the day.

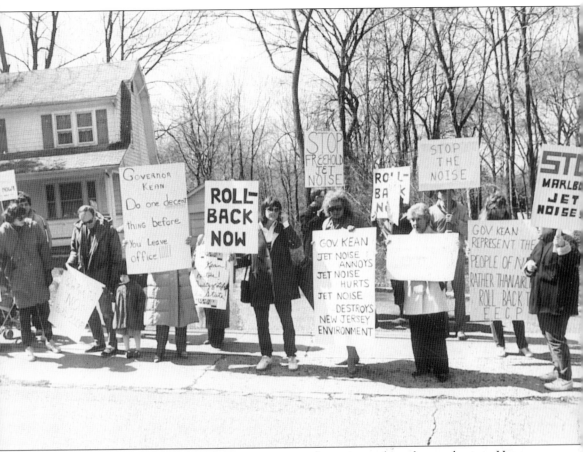

Livingston's citizens are never reluctant to express their views when the need arises. Here a group of property owners holds signs urging Governor Kean to take steps to prevent further jet noise from afflicting the community. In April 1989, when this picture was taken, Kean was governor and a resident of Livingston.

Governor Jim Florio was engaged in his campaign on this occasion when he visited Livingston. He is shown here with Councilmen Joe Fiordaliso, Bob Leopold, and Patricia Sebold (chair of the Livingston Democrat party for many years and now Essex County freeholder).

The author had the privilege and pleasure of serving as township attorney from 1975 until 1987. His duties included drafting ordinances, providing legal opinions to the township council, and serving as the town's lawyer in the occasional litigation involving the town.

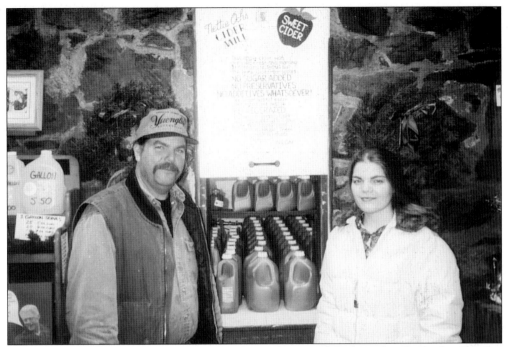

Robert Ochs and his daughter Julia oversee the production of the latest batch of cider. One has the feeling that, just as there will always be a Livingston, there will always be a Nettie Ochs Cider Mill.

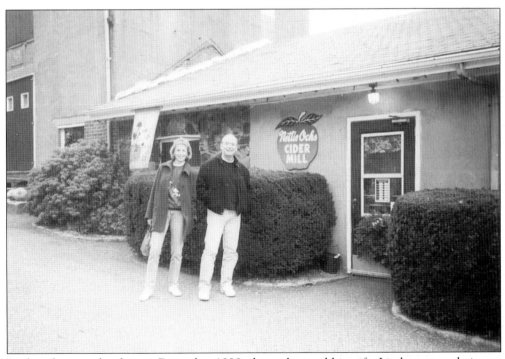

In this photograph taken in December 1998, the author and his wife, Linda, are on their way into Nettie Ochs Cider Mill for some apples and hot-mulled cider.

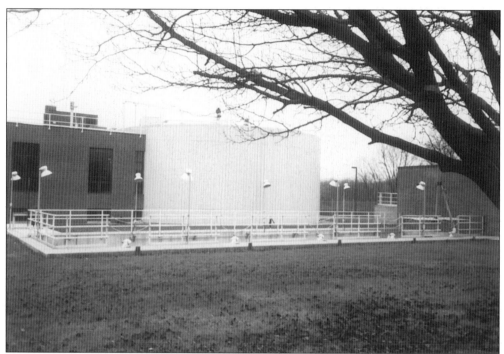

In 1938, the local newspaper urged that the installation of a modern sewer system was critically important. A system was installed, but by the 1970s it had become outmoded. Environmental laws had changed and the town had grown. Accordingly, plans were put in place to build a new and modern plant. This photograph shows that plant as it exists today.

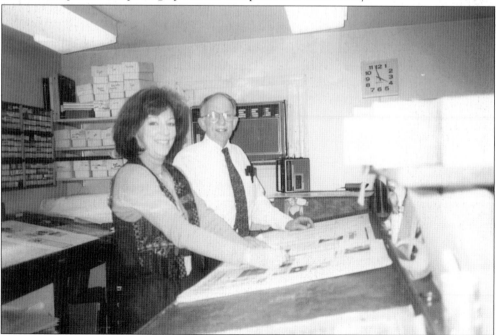

E. Christopher Cone, editor of the *West Essex Tribune*, is shown here with managing editor Nancy Dinar as they wrap up the 1998 Christmas edition.

Here are four of Livingston's most prominent citizens. From left to right are Shari Weiner (former councilwoman and current volunteer in any number of areas), Richard Vallario (former attorney to the planning board and now municipal court judge), Robert Leopold (former mayor and councilman and present chairman of the planning board), and Dominick Crincoli (former mayor and councilman).

Township Manager Charles J. Tahaney (right) and Deputy Township Manager Russell Jones are seen here at the desk of their secretary, Pat McAnally. All three live in Livingston. Both Chuck and Russ had the opportunity to learn a great deal about the operation of municipal government when they worked under Robert H. Harp.

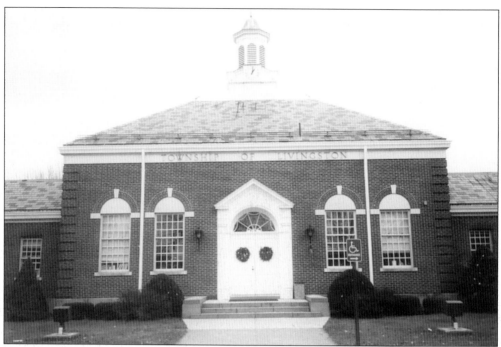

The town hall is shown here on Christmas Eve 1998.

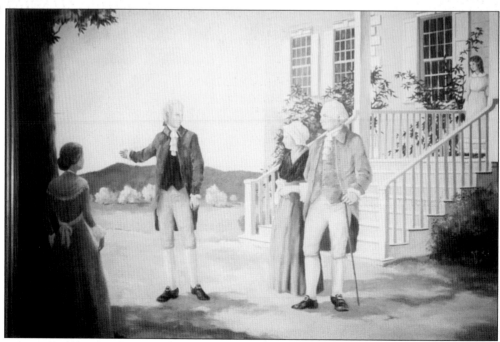

Governor Livingston (with his arm extended) confers with George Washington during a trip by the first President to New Jersey. The painting hangs in the reception area of the town hall.

This house on Burnet Hill Road is decorated for Christmas. During the holiday season, hundreds of sightseers come to witness this wonderful spectacle.

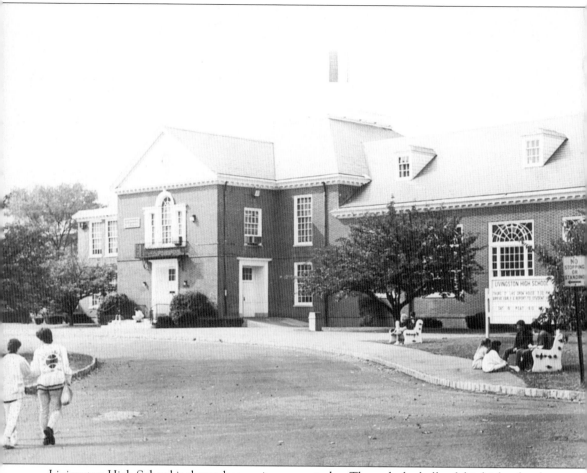

Livingston High School is shown here as it appears today. Through the halls of this high school pass many of the young men and women who represent Livingston's future.

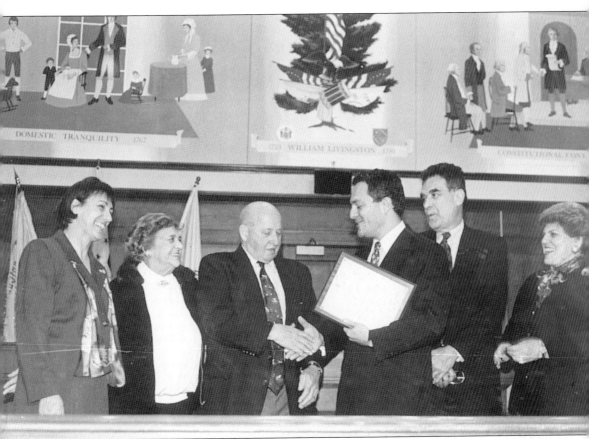

This was the township council meeting of Monday, December 21, 1998. Councilwoman Dolly Luwisch is on the left, and Councilwoman Eleanor Cohen is on the right. Next to Ellie is retiring Councilman Stanley Weinroth, and next to him is Mayor David Katz shaking hands with Charlie Schilling. Schilling is being presented with a certificate of recognition, for in the year 1998 he had already responded to over 700 calls for help from the First Aid Squad. Marie Schilling stands next to her husband and looks on approvingly.

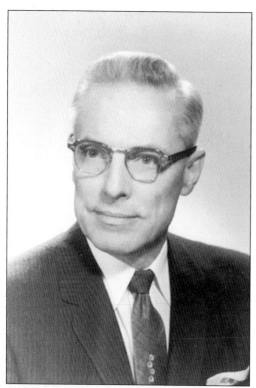

As has been noted elsewhere in this book, to say that Bill Clark played an important role in the planning for Livingston's development, especially after World War II, would be similar to suggesting that Joe DiMaggio played an important role in the history of the Yankees. It is fitting that the town hall complex is named in his honored memory.

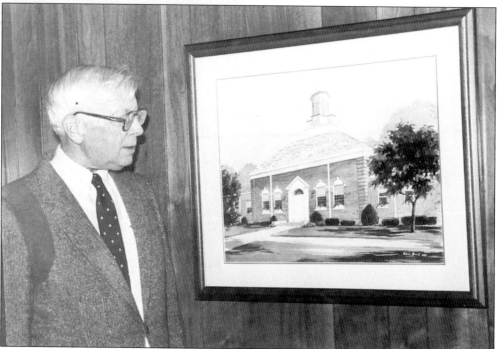

Bob Harp views a portrait of the town hall by local artist Edwin Haves. This picture was taken on October 10, 1985. Bob Harp lived and breathed Livingston. He came here in 1957 and, in words taken from Robert Frost's *The Road Not Taken*, ". . . that has made all the difference."